IMAGES
of America

PORT ORFORD AND
NORTH CURRY COUNTY

This aerial view of Port Orford around 1940 shows beaches to the west and south. Garrison Lake, said to be named for a very early settler, is northwest of town; the dock is in the lower center, projecting near a short point of land. East (right) of the dock is Fort Point, and to the right of that is Battle Rock. The prominent point extending southwest from the town has been known variously as Point Orford, Coast Guard Hill, or simply, the Heads. In the cove at its southern base are a boathouse and concrete breakwater, part of the Port Orford Lifeboat Station. On top of the headland, to the left of the boathouse, are the station buildings with a residential area nearby, surrounded by trees. U.S. Highway 101 can be seen in the upper center, approaching from the north. It curves slightly, passes straight through the town, then curves to proceed eastward on its way to the next town. (Curry Historical Society.)

ON THE COVER: These were most of the musicians who played at the opening of Gilbert Gable's dock in 1935. The tuba player at rear left is Gene White. He was Port Orford's town marshal and water superintendent. He played in an earlier town band pictured in chapter four. Behind the band is the raw cliff face, resulting from blasting to get rock for the jetty and dock. (Pat Masterson Collection.)

IMAGES
of America

PORT ORFORD AND NORTH CURRY COUNTY

Shirley Nelson

ARCADIA
PUBLISHING

Published by Arcadia Publishing
Charleston SC, Chicago IL, Portsmouth NH, San Francisco CA

Printed in the United States of America

Library of Congress Control Number: 2010923455

For all general information contact Arcadia Publishing at:
Telephone 843-853-2070
Fax 843-853-0044
E-mail sales@arcadiapublishing.com
For customer service and orders:
Toll-Free 1-888-313-2665

Visit us on the Internet at www.arcadiapublishing.com

*To the pioneers, past and present, who have fallen in love with
our area and stayed to help make it the unique place it is.*

CONTENTS

ACKNOWLEDGMENTS

I am grateful to several museums and organizations for their help in obtaining photographs and information: Coos Historical and Maritime Museum (Hannah Contino), Curry Historical Society (Meryl Boice, Jackie Kerska, and Marian Davis), Oregon Historical Society (Scott Daniels and Scott Rook), Point Orford Heritage Society (POHS, Steve Roemen), and the scanned computer files of Alan Mitchell. I could not have done this project without the photographs of the late Patrick Masterson, which are now in the possession of the Friends of Cape Blanco. Photographs from the Pat Masterson Collection are credited in the text as PMC.

Thanks to the people who loaned photographs and/or provided information: Gary and Norma Anderson, Grace Bonnell, Mary Capps, Myrtle Clark, Rick Cook, Bonnie Cox, Jack Donaldson, Lucile Douglas, Laura Eades, Bill and Thelma Foster, George and Muriel Gehrke, Brent and Wayne Hodge, Doug Jamieson, Mike Knapp, Lloyd and Geraldine Kreutzer, Martha Lane at Pacific High School, Pauline Lenox, Jean Marsh, Dot Mathews, Dolores Mayea, Thelma Nodine, Clyde Quigley, June Sabin, Frank Smith, Ray Smith, Kim Stang, Stephen Thompson, Dixie Tucker, Shirley Van Loo, Brice Wagner, Kent and Peggy Wagner, and Leon White. And thanks to the six people who read the manuscript and made suggestions for improvement: Lucile Douglas, Theresia Hewitt, Dolores Mayea, Alan Mitchell, Brice Wagner, and Leon White. We did it together.

Finally, I owe a debt to those historians who went before me and published books on local history: the 10 people who put together the Langlois Centennial book (1981); Pat Masterson, *Port Orford a History* (1994); and Pattie Boice Strain, *Floras Creek Precinct* (2003). Each book is unique and contributes to our knowledge of our past. These books are available at the Port Orford and Langlois Libraries. I have also consulted several other published historical accounts; names are spelled as they were in photograph collections or historical documents.

INTRODUCTION

An early Port Orford visitor observed, "Port Orford is a little hamlet on the wrong side of the mountain with no reason on earth for being there." The town might not exist if not for energetic entrepreneurs who tried to improve and promote the area, such as William Tichenor, Louis Knapp, and Gilbert Gable.

Explorers from England, Spain, and Russia, sailing past as early as the 16th century, knew the area long before settlement. They noted the large deepwater bay, without a river bar to cross, and they might have taken fish, seals, or sea otters.

An early Spanish explorer supposedly gave the name Cape Blanco to a prominent headland, the farthest west in what is now Oregon. British captain George Vancouver came in 1792, sighted the headland, and called it Cape Orford in honor of his friend George, Earl of Orford. Mariners continued to use the name Cape Blanco. Captain Tichenor gave the name Orford to the town he founded in 1851.

Archaeologists say Native Americans have lived along the West Coast of North America for thousands of years. Natives hunted, fished, and gathered plants, rocks, shells, and driftwood, which provided food, clothing, tools, and shelter. Generally, the people lived a good life.

In early contacts with explorers, the natives seemed curious and friendly, while later encounters described the people as hostile, fearful, or suspicious. The difference was possibly due to the way different ship captains and crews treated natives. The natives in the area described in this book were of Athabascan stock. Different bands spoke different dialects, and each band had a place where they hunted, fished, and lived in a village. They might have lived in seasonal camps to harvest fish or shellfish. The people who lived closest to Port Orford were the Quah-to-mahs.

To the European American white man, the area was part of Oregon Territory in 1851 and was in Jackson County, which comprised the whole southwest corner of what would become the state of Oregon. When smaller counties were created, Port Orford was in Coos County in 1853 and, finally, Curry in 1855. A post office was established in Port Orford in March of that year. When the new county was formed in December, the town became the first county seat of Curry County and remained so until Oregon achieved statehood in 1859. The seat of government was then moved to Ellensburg (later Gold Beach), south of Port Orford. Ellensburg was said to be named for Captain Tichenor's daughter, Sarah Ellen.

Curry County is about 75 miles long from the California border on the south to the Coos County border on the north. This book covers the northern 15–20 miles. A narrow plain running north and south between the seacoast and the Coast and Klamath mountain ranges allows for some crops and stock grazing. The Elk and Sixes Rivers flow from the mountains westward into the ocean, as do smaller streams. The name "Sixes" was most likely an attempt by early settlers to pronounce a native word.

Gold attracted the earliest settlers. Captain Tichenor recruited men with the promise they could get rich. As they came to follow the newest discoveries, miners disrupted the natives' way

of life. They trampled hunting grounds and treated native villages as unimportant, with their hydraulic hoses washing dirt into fishing streams.

The 1850 Donation Land Claim Act allowed settlers to possess land, though no treaties had been negotiated with natives. Native Americans had no concept of individual ownership of land, but they and their ancestors had lived on and used the land and resources for countless generations.

As miners became more numerous and more aggressive, small and large conflicts erupted. Natives defended their ancestral homeland, and miners defended what they believed to be their rights to live on the land and take what they wanted.

About the time Port Orford began, gold was discovered in Jacksonville and elsewhere in the southern interior of Oregon. Miners tried to deal with (read "exterminate") the natives. Through the efforts of Native American agents, treaties were made, not always ratified, and sometimes broken. Fighting that began in the upper Rogue Valley moved down the river. More miners came to the coast and exacerbated the situation. Each community in Curry County had its group of men, mostly miners, who dealt with the natives independently of—and often at odds with—the regular army. Whether they were called "Gold Beach Guards," "Port Orford Minute Men," "Vigilance Committees," "Fire-eaters," or "Volunteers," the result was the same.

War erupted intermittently from 1851 until the peak of fighting on the coast in 1855–1856. Decisive battles left the natives with the realization that they could not hope to overcome the invasion of the white man. Reluctantly, they surrendered. Captain Tichenor was paid to find, capture, and deliver native survivors. After they were delivered to a stockade at Fort Orford, several hundred were taken by ship north to their new home on a reservation. Others were marched overland. A few managed to hide and remain in their familiar area; some returned from the reservation to try to resume their way of life.

As Port Orford was being settled, newcomers moved into other areas of the north county. Settlement developed around gold mines several miles up the Sixes River. The first Sixes post office was in a large gold camp. Later the village of Sixes grew up about 5 miles from the ocean at the point where the main road—later U.S. Highway 101—crossed the river. In 1876, widow Charlotte Guerin, sister to Captain Tichenor, moved from New Jersey to a remote area close to the headwaters of the Sixes River. She and her son, daughter-in-law, and five grandchildren joined Joseph Haines and his family at New Castle, later named Eckley. The community raised animals and crops and sold food to miners.

The first settlers at Langlois and nearby Denmark obtained land and started farming, many as dairy farmers. Others came and provided services such as blacksmithing, stores, and lodging.

Transportation was by sea and by land. Most newcomers arrived by ship, as did freight. On land, one could walk or ride a horse. In the last years of the 19th century, travel was by horse-drawn wagon or coach over roads that were rough, narrow, and muddy in rainy weather and curved around stumps or other obstacles. Streams were forded for lack of bridges, affecting the delivery of mail and other goods.

People could go north to Portland or south to San Francisco by steamship, and at either city train travel was available to the eastern states. After 1893, travelers could go north to Marshfield (now Coos Bay) and take the train to Myrtle Point on the Coquille River. Steamboats also traveled up the river from Bandon.

Port Orford, due to its isolated location and small population, has had to struggle to survive; yet, survive it does. It was the first settlement in Curry County, the first town to incorporate, and has, along with the rest of the north county, supplied at least 10 state or territorial legislators and more than a dozen county commissioners over the years, as well as other county officials.

One

BIRTH AND
EARLY DEVELOPMENT

Port Orford rode a roller coaster during its first 50 years. The first settlers established dwellings and businesses and defended themselves against hostile natives. Gold seekers found enough to keep them digging, and the settlement grew. In 1852, Oregon land claims officials, checking on Port Orford, reported that the town had about 60 buildings: one sawmill, three hotels, eight stores, two saloons, one ball alley (bowling), one mine, and 14 structures in a U.S. garrison (Fort Orford).

An 1854 visitor described the town as "lively . . . with about 1,000 inhabitants." He reported many stores, hotels, and saloons and much business done by miners. Around the time the Rogue River Indian War ended in 1856, some mines failed, and many miners left. One report listed 35 houses, 100 people, and 25 soldiers. In a few years, only three families remained: Burnaps, Louis Knapp and his mother, and the William Tichenor family. Saloons, stores, and five hotels were vacant.

A forest fire destroyed the town in 1868, leaving only the Tichenor house, the stables of the Knapp Hotel, and one or two other buildings. Determined people stayed, and others came. Louis Knapp constructed a new hotel in the early 1880s.

Some mines continued to operate. Logging and saw milling continued, and shipments were made by sea. Port Orford was a port of entry for a few years, requiring customs collectors. As Marshfield developed in Coos County to the north, it became the entry in about 1867. Port Orford's importance as a port waxed and waned and was declining in the late 1880s.

A strong earthquake occurred in 1873 with minor damage and no report of injury or death; settlement was still sparse. Local rivers flooded in 1890, and three people were killed in a landslide on the Sixes River.

Settlers often had more than one source of income, such as a farm and a store or a gold mine. They might work part of the year in the logging industry or fishing. This pattern has persisted through the years. Even today, locals seek employment in Coos County.

Native Americans on the coast of Oregon Territory constructed dwellings made of wood, which was readily available from the beach or forest. The structure had an entry hole, a fire pit in the floor with an opening in the roof for smoke, and earthen benches along the sides for storing blankets, baskets of food, and other items. (Curry Historical Society.)

Pacific Mail Company's steamship *Columbia* traveled safely between San Francisco and Portland, Oregon, from 1850 to 1862. The *Columbia* stopped at Battle Rock in 1851, delivered soldiers to Fort Orford, transported native survivors of the Rogue River Indian War north to a reservation, carried freight, and brought Port Orford settlers who stayed. She was 193 feet long, weighed 777 tons, and had a 70-foot-long dining room. (PMC.)

A sailor since his teenage years, Capt. William Tichenor navigated a regular route between San Francisco and Portland, Oregon, in the 1850s. Exploring the Oregon coast, he found a large deepwater bay about halfway between the two cities and resolved to get a Donation Land Claim there. He was born in Newark, New Jersey, in 1813, the youngest of six boys in a family of 10. Between sailing trips he spent time in different states, farming, keeping shops, and participating in politics. He married Elizabeth Brinkerhoff in 1834; they had two daughters and a son. In 1849, he mined gold successfully on the American River in California. The captain owned or sailed on several different ships; his ship *Sea Gull* brought the first settlers. Supporting and serving the community he started, Tichenor was a state legislator and county commissioner. He died in San Francisco in 1887 and was buried in Port Orford on what some call "Spyglass Hill," overlooking the Pacific Ocean. (Oregon Historical Society Image No. bb006490.)

In June 1851, Captain Tichenor recruited nine men in Portland and left them on this beach. They climbed this rock with supplies and guns. Later fighting left several natives dead; the would-be settlers escaped on foot after dark. Known since as Battle Rock, the rock and adjacent hillside became an Oregon State Park wayside between 1930 to 1981. The property is now a Port Orford city park. (Lucile Lindberg Douglas.)

Ralph Erastus "Jake" Summers, one of nine men who fought Native Americans at Battle Rock, later returned to the area and married Betsy Taylor, a Coquille Indian. Their marriage was the third to be recorded in Curry County; they had 10 children. Jake mined gold on the Sixes River and later settled on a farm on Floras Creek. Jake, Betsy, and their son, Ralph, are buried on Battle Rock. (Pauline Lenox, descendant.)

"Port Orford Jakie" lived in the area until his death in the early 1900s. Known to local residents, he liked to dress in this fashion for special occasions. He might have been a chief of the band of Native Americans who lived south of Port Orford or of the Quah-to-mahs in the immediate vicinity. Perhaps he witnessed the Battle Rock conflict. (Oregon Historical Society Image No. bb006355.)

Captain Tichenor returned later in the summer of 1851 with more than 60 men he recruited in San Francisco by promising them lucrative gold mining. The first structures built were two blockhouses on a headland, later called Fort Point. The blockhouses provided safety in case of a Native American attack. In 1852, Tichenor brought his wife and children to the settlement, possibly the first Caucasian family on the Oregon coast. (PMC.)

Humbug Mountain, just south of Port Orford, stands 1,756 feet high, the tallest Oregon coast mountain dropping directly into the sea. In 1851, it was called "Sugar Loaf Mountain." Tichenor wanted to bring mining supplies into Port Orford by sea then overland to miners in the interior; he sent men to find a route, starting at the mountain. They endured hardships, got lost, and renamed the mountain "Tichenor's Humbug." (PMC.)

Helped by Tichenor's efforts, soldiers began building Fort Orford in September 1851; it was occupied until the end of the Indian Wars on the south coast in 1856. The number of resident soldiers fluctuated from 9 to 244. Some officers later served with distinction in the U.S. Civil War. In September 1856, some Fort Orford buildings were moved north by ship to become part of Fort Umpqua. (PMC.)

Common murres nest in large colonies on rocks off the Oregon coast. From the 1850s until the 1930s, fishermen climbed dangerous rocks and cliffs to collect the eggs, which were prized by San Francisco bakers and brought a good price. Fishermen's wives and children cleaned and packed the eggs for shipment. The Forty family was involved in this egg business for about 60 years. The murre eggs provided income for people willing to do the work. The shape of the eggs helped prevent them from rolling off the rocks. When the gatherers arrived, the birds left the area; when they returned to find their eggs gone, each female would lay another. By 1935, overharvesting of the eggs all along the coast made collecting them illegal. (Above, POHS; below, PMC.)

Cape Blanco Lighthouse was built in 1870 to warn mariners of hidden reefs. Originally fired by oil lamps, it was electrified in the 1930s and automated in 1980. The Aid to Navigation is the oldest remaining Oregon lighthouse and the farthest west in the state. Two keepers and their families lived in the duplex. (U.S. Coast Guard Museum Northwest.)

William S. Winsor was a very early resident of Port Orford. He is said to have built the town's first jail in 1858. Winsor was engaged in several business enterprises, one of which was this hotel and store that he built in 1874. Later the Bennett Hotel across the street burned, and this structure became the Bennett Hotel and store. (PMC.)

The Nygren Hotel, built in 1888, was used as an inn and stage stop. This modern photograph shows the basic structure as it appeared originally. The interior is currently divided into rental apartments. (PMC.)

Walter Sutton came to Oregon by covered wagon and lived several places, arriving in Curry County in 1870. He published newspapers, including the *Port Orford Post*, *Gold Beach Gazette*, and *Port Orford Tribune*. Shown in 1889 are, from left to right, (front) Luly Alpha, Mary Gertrude, and Walter Frank; (on the mule) John Adam, Bertha Francis, and James Henry; Walter stands behind the mule, and Louesa Annie is at right. (Carol L. Crockett, descendant.)

New Zealander William John Blacklock came to north Curry County in the late 1800s. He found large deposits of sandstone above the beach and, with others, formed the Blacklock Sandstone Mining Company. They acquired land and built a sawmill, homes, tramcars, rails, and a wharf. A post office—Sandstone—operated for a few months. After 1886, mining began. Blocks of high-quality sandstone were quarried, sent by tramcars down to the beach, and lightered to ships, which carried them to San Francisco. It is locally believed that several San Francisco buildings were partially constructed of Blacklock sandstone, though documentation is lacking. The company ceased operations in a few years, due to the difficulty of loading and shipping the stone. No trace of the operation remains. Blacklock children married into local families. (At left, POHS; below, PMC.)

P. J. LINDBERG

Swedish-born Pehr Johan Lindberg went to sea as a young boy, visiting many countries. He eventually came to San Francisco where he learned carpentering, bridge building, and plumbing. After practicing those trades in California for a few years, he came to Port Orford in 1882, starting what could be called the "Lindberg Era." Among the structures he constructed in Port Orford were the 1909 head keeper's residence (demolished late 1960s) at Cape Blanco Light Station and the 1898 farmhouse of Patrick and Jane Hughes, which has been restored and is open to the public. Lindberg also was an undertaker and served as town constable and county commissioner. He was married to Savannah Wilson Lane who had six children by her first husband. She and Lindberg had two boys. (Lucile Lindberg Douglas, descendant.)

This house was built by P. J. Lindberg in 1891 for the mother of Charles A. Long and was referred to over the years as the "Long house." It originally had nine rooms with 9-foot ceilings. The house still stands but has been remodeled inside and out. Charlie Long operated a grocery and general merchandise store in Port Orford for more than 25 years in different locations. (PMC.)

In 1895, F. L. Randall constructed a house overlooking the Sixes River. In 1918, Bert and Anna Wells moved and enlarged the building, operating it as Sixes River Hotel from 1920 until 1942. A private home for 40 years, the building was purchased from Sam and Viola Cuatt by Eric and Marilyn Oberbeck who restored it, opening it as a hotel in 1993. It is once again a private home. (PMC.)

P. J. Lindberg built this home in 1896 for himself and his family. He used the same basic design for the historic Hughes House. His granddaughter Lucile, 91 years of age, is living in the home at the time of this writing. She is the daughter of his son Edward. This home is in downtown Port Orford; Hughes House is north of town, near Cape Blanco Lighthouse. (PMC, Lucile Lindberg Douglas.)

The "Masterson House," as it was known, was built by P. J. Lindberg in 1898 for Patrick Hughes's daughter Alice and her husband, Patrick Masterson. Lindberg used the same basic design for this house as for his own home in town and Patrick Hughes's house near the Sixes River. The house was occupied by later members of the Masterson family, then became the Masterson Hotel, and finally the Seaside Hotel in the 1920s. Today it is once again a private home. (PMC.)

Grand Ball

AT LENEVE'S HALL, PORT ORFORD, OR.,

ON THE

Evening of March 17th, 1897.

FLOOR MANAGERS
P. J. Lindberg, Wm. Neathery, Wade Wilson.

No........ . 　　 TICKETS (Including Supper) $1.00.

Port Orford residents did not spend all their time making a living in a pioneer settlement, as indicated by this announcement. One of the men listed on the ticket is pioneer builder Lindberg. Obadiah Leneve had a drugstore in town for several years at different locations. One building, which still exists, had space for dancing or basketball games on the upper floor. (Lucile Lindberg Douglas.)

Louis Knapp and his mother arrived in 1859 and worked at a hotel, which Louis later owned and an 1868 forest fire destroyed. In 1883, Knapp built this hotel. In 1899, Louis stands with sons, Orris and Louis Jr. Inside the fence are, from left to right, Bob Forty, John Wilkinson, W. R. Johnson, William S. Winsor, Frank Smith, Ella Knapp, Ruby Junkins, Ames Johnston, unidentified, and Dennis Cunniff. (Mike Knapp, descendant.)

Two

THE RESOURCES
WERE GREAT

Two rich resources were exploited early: gold and trees. Gold nuggets and flakes lay in streambeds, gravel bars, streamside banks, and underground, and small particles could be found in black beach sand.

In the early 1850s, a man named C. G. (or "Coarse Gold") Johnson discovered gold on a northeastern Curry County creek, later named for him, near Salmon Mountain. Jake Summers and others discovered gold at the mouth of Rock Creek on Sixes River about 1855 and mined successfully for 30 years. In 1886, two Moores, Frank Smith, Marshall Nay, and three Kronenbergs filed on 160 acres for placer mining at Salmon Mountain. An 1889 fire destroyed equipment; the rebuilt mine was operated by William D. Wasson and Sons.

At one time, 150 men worked on the Sixes River, Johnson Creek, and south fork of the Coquille River. Five hydraulic mines worked on Sixes River and two on Johnson Creek. A large company, Inman Mines, operated on the south fork of Sixes River near its junction with the main river from the early 1900s to late 1920s. Several Elk River tributaries produced gold.

Some men mined as a second job; some invested money in mines. Mining involved risk, as the price of gold fluctuated. Some could earn more money working in a lumber mill.

In 1853 or 1854, William Tichenor asked relatives to start a sawmill with timber from his own land claim. That first Curry County mill employed 25 people. Lumber from locally abundant white cedar was shipped to San Francisco.

Some names in logging and milling were Joe Nay, Crawford and Wilbur, Nick Marsh, and Peterson. Nay bought the remains of a mill after the 1868 forest fire. In 1884, the schooner *Mose* wrecked in the harbor with a loss of 60,000 board feet of Nay lumber.

From about 1870 until the mid-1880s, a mill at Hubbard Creek, under various owners, employed about 60 men. A tramway from the creek mouth west to a large rock in the ocean transported lumber to the rock, which had a dock attached. Lighters were loaded and towed to schooners for shipment.

Tucker Mill in Langlois operated into the late 20th century.

Extracting gold from sand or gravel deposits left by a river or glacier is called placer mining. Some gold lies close to the surface and is easy to remove. In streams, gold-bearing material can be dredged from the bottom. Where gold was buried in banks above streams, hydraulic mining was often used. Water was forced at high pressure through hoses aimed at the banks to wash away the gravel and reveal the gold. This method involved damming a stream, running water through flumes or pipes, often for a great distance, and then through hoses. This required equipment, aided by gravity, and used a lot of water. The big hoses and nozzles were called "giants." The final step involved running the gold and gravel through sluice boxes, again using water, to separate the gold from the gravel. (Both, PMC.)

The Sixes River mines were in rugged country, as shown in this photograph (right). The pipe bearing water for hydraulic mining can be seen at the lower right, just above the river. Such pipes were usually made of wood, with iron bands; they carried water from a stream to a mining area. The diameter of the pipes narrowed from 34 inches to 22 inches (iron pipe), with a 15-inch pipe close to the nozzle. Note the sturdy construction of the trestle bearing the pipe. The Inman Mines in the 1920s comprised 30 mining claims and owned 2.5 miles of the Sixes River below and above the forks. The company, which had a large camp and facilities 13 miles from the main road, went into receivership in 1929 and was purchased by Gilbert Gable's Oregon Engineering Company in 1933. (Both, PMC.)

A crew builds a trestle in this image. Note the size of logs used and the hydraulic giant behind them. In the background, buildings and another hydraulic stream of water can be seen. Though the men look idle for the photograph, they might have been grateful for a few minutes of rest. Construction equipment and mining, whether by blasting, pick and shovel, dredging, hydraulic systems, or shoveling and sluicing, was hard work. The massive amount of debris from this method of mining changed the character of streams and destroyed the natural habitat. (PMC.)

Workers at Big Jewel Mine are shown around 1905 on the Sixes River at the mouth of Dry Creek. They are, from left to right, (first row) O. J. Mather, Deed Fitzhugh, Cleve Cox, Mill Fitzhugh, Iney Dell Post, and George Guerin; (second row) Alfred Haft, Paul Martin, Jim Haft, two unidentified, Court Guerin, Charles Fitzhugh, Fred Post, "Dad" Corbin, and Ash Cook (the last man standing on the first step). The other seven are unidentified. Amaziah or his brother, Charlie Jamieson, owned the mine. (PMC.)

The wooden structure houses equipment used for beach mining. Usually miners shoveled sand, over and over, into a sluice box, which had several ridges or cleats to capture the gold when water was washed through. Cyrus Madden operated a successful black-sand mine south of Cape Blanco for about 40 years starting in the late 1850s. Madden Butte, south of Pacific High School, is named for him. (Alan Mitchell.)

The Jamiesons were also involved in a sawmill at Sixes River in the early 20th century. Early logging was done with axes and hand saws; logs were transported by teams of oxen or horses pulling sleds and, later, wheeled trailers. Hauling logs to a mill or to the port to be shipped whole became easier after gasoline-powered trucks such as this one, shown *c.* 1930, were available. (PMC.)

Jake (left) and Jim White drive a *c.* 1920 truck, another early vehicle with hard rubber tires, which is loaded with cedar logs. The local white cedar was said to be named "Port Orford Cedar" by William S. Winsor. It is also called Lawson Cypress, though some scientists say it is neither cedar nor cypress but a separate species. The tree grows naturally in a limited area of southwest Oregon and northwest California. (PMC.)

Jerry Boice (left) and Harold Whitsett stand with their "one load" around 1936. The first trees that were cut in Oregon forests had grown to great size. Only a portion of a large fir tree could be carried on one truck, and such loads were quite common. A log of this size would yield many sawn boards for building houses. The man at the rear of the truck is unidentified. (PMC.)

Myron Forty stands with a load of Port Orford cedar around 1940. Logs not shipped whole were taken to sawmills to be cut into boards. The wood was used to build ships, homes, battery separators, and anything that needed to be very straight, such as arrows. Attractive when finished, Port Orford cedar is also used for furniture, musical instruments, and carvings. This truck belonged to Nick Marsh Logging Company. (PMC.)

Asmus Adolphsen of Denmark came to Denmark, Oregon, north of Port Orford, in the late 19th century. After arriving in 1854, he went back to Denmark to marry Anna Festerson and returned with her. Known as the "sawmill man," he had mills consecutively in several places by about 1900: his Denmark homestead, downtown Langlois, Wilbur Sypher property, and two or three locations on Elk River. One mill cut and shipped only hardwood (oak). The above image is dated about 1905 and the one below about 1910. (Both, PMC.)

Fred Adolphsen, a son of Asmus, worked in his father's timber business. One old photograph shows him with an early Caterpillar tractor in the logging woods. He lived with his sister Katie for many years. Fred and Katie helped saw Adolphsen lumber to build their house. All the Adolphsens were well known in the area and participated in community activities. (PMC.)

Another son, Henry Adolphsen, also worked for his father. Later he had his own logging company and employed 65 men. He married Florence McKenzie after a long courtship and helped with the work on her family's ranch. After she died, Henry married Mary "Ma" Woodworth, a widow (left). The couple enjoyed traveling and supported local organizations such as 4-H and hospitals. (PMC.)

The Norman Larson mill was located on Jackson Street between Tenth and Twelfth Streets around 1915. Jackson Street was a main north-south thoroughfare in town and was the highway for some years in the early 20th century. Businesses located there because of the traffic passing by, though lumber mills were usually located on the edges of town, closer to the timber supply. The Larson mill operated until about 1925. (PMC.)

Old-growth trees were still being cut in southern Oregon coast forests in 1959, the date of this one-log load, and for some years afterward. The two men are unidentified. (PMC.)

This load of Port Orford cedar logs was destined for Japan about 1923. The logs would be loaded on the SS *Frogner*, a large ship that called at Port Orford in the early 1920s. Port Orford cedar is strong, straight-grained, dense, and resists rot and insects, making it an excellent building material. The tree is similar to four species that grow in eastern Asia, and the Japanese have used a great deal of it for temples, coffins, and fine homes. The unidentified driver in this image worked for Adolphsen. (PMC.)

The Trans-Pacific Lumber Company crew takes a break during construction of the mill around 1934. Gilbert Gable had the mill built where Buffington Park is today. It operated for a few years, and local people had high hopes for the future of the business. The largest mill in the area at the time, Trans-Pacific was finishing lumber at the rate of 25 million feet annually within a year of its formation—enough to fill 25 or 30 ships. It was said to have shipped more lumber in 18 months than was shipped from 1854 to 1887. Mill workers played on a company-sponsored basketball team, and Trans-Pacific supported the community in other ways. (Both, PMC.)

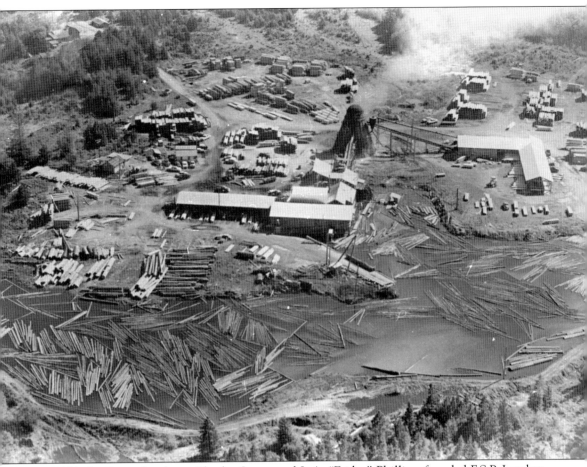

In 1951, the Foster brothers, Charles Storm and J. A. "Friday" Phillips, founded F.S.P. Lumber Company, which retained the name even after the Fosters left in 1952. A September 1957 fire destroyed the mill near Langlois. Storm and Phillips rebuilt off Cape Blanco Road. The mill above opened there in 1959. New owners bought the mill in the early 1960s and operated it until the mid-1970s. Cranberry bogs now occupy the area where the mill was located. (PMC.)

The F.S.P. logging crew is, from left to right, (first row) John Cox, unidentified, Bill Stewart, Mr. Smith, Dick Hofsess, Norvel Phillips, two unidentified, and Donald Phillips; (second row) Ernest Storm, Keith Nodine, Mr. Clawson, Mr. Bowman, Pete Peterson, Darrell Price, Mel Woodcock, Glenn McPherson, and unidentified; (third row) Dick Everest, John Bowman, unidentified, Jiggs Storm, Bill Berger, two unidentified, and Floyd Miller; (fourth row) Harvey Hiley, Floyd Brown, unidentified, Mr. Murdock, "Pup" Robbins, Dale Belanger, and four unidentified. The men in the photograph below formed the 1955 F.S.P. mill crew. Among those in the mill crew are owners Friday Phillips and Charles Storm. Some of the men are also pictured in the logging crew. (Both, PMC.)

Three

LANGLOIS AND THE DAIRY INDUSTRY

In 1828, Jedediah Smith's company of explorers camped at Sixes River on their way north along the Oregon coast. Smith's assistant, Harrison Rogers, wrote in his journal: "The country for several days past well calculated for raising stock, both cattle and hogs." Less than 50 years later, people were doing just that.

In 1854, William V. Langlois settled on Floras Creek, his name eventually given to the town halfway between Port Orford and Bandon. Between 1852 and 1900, families settled on Floras Creek and northward. Alexander Hamilton Thrift came in 1856, discovered gold, and made money, which he invested in property. He developed a dairy farm, as did Partick Hughes (arrived *c.* 1861) on Sixes River, Charles W. Zumwalt (1869) on Sixes River, Robert McKenzie (1875) at the mouth of Elk River, and Alfred Marsh (1883) on Elk River. The following, with their arrival dates, established dairy farms in the Floras Creek/Langlois area: James E. Hawkins (1884), William Cope (1887), George Bethel (1887), George Farrier II (1888), and Frank Langlois, son of William. Some other early names in the dairy industry were Hurst, Knapp, Sutton, Boice, Guerin, Long, Capps, and Jensen.

In 1878, Danish Nicholas Lorentzen founded Denmark 2 miles south of Floras Creek. He operated a hotel, store, saloon, and lumber business. More Danish people came, including Haagensen, Jensen, Adolphsen, Olsen, and Cox, among others.

Because of all the dairy cattle, people called the larger settlement of 600 people Cowtown or Dairyville. Though a post office was established for Langlois in 1881, the name Dairyville persisted.

In the late 1890s, Dairyville had two hotels, two cooper shops, a store, wagon shop, blacksmith shop, harness shop, feed stable, school, creamery, and printing plant. Historian Orville Dodge came through in the late 1890s and wrote that he traveled on "a good wagon road." He remarked on the importance of Dairyville.

At the end of the 19th century, post offices existed at Langlois, Hare (on Langlois Mountain), Denmark, Sixes, Port Orford, and Eckley. The north Curry County communities were interdependent.

Alexander Hamilton Thrift, with others, discovered gold north of Bandon in 1856. After working the claim for a while, the partners sold the mine; Thrift was paid $11,000. This sum helped him buy property such as this farm on the south edge of what became Langlois. Although the town was officially Langlois from 1881, it was always "Dairyville" to Thrift, one of the more influential men in its development. (June Sabin.)

Though cows on the southern Oregon coast can remain in pastures nearly all year, hay is sometimes needed. Here, from left to right, George Sydnam, John Capps, Hawes Sydnam, and Raymond Capps pause from piling hay into shocks at Denmark. The quality of grass that grew in the area was one of the factors in making it a good place for cows. (Curry Historical Society.)

By July 1890, this bridge, built by Miles H. Chenoweth, was completed over Floras Creek when two spans—100 feet and 50 feet long—were joined. As with most early bridges over Floras Creek, it was later taken out by high water. Meanwhile, several unidentified people experience different ways of traveling with horses. (PMC.)

Langlois was young in the early 20th century. The false-front building with a large door open at center right is a livery stable. At left, the structure with a covered porch between the two false-front buildings is a boardinghouse constructed by Annie Lorentzen after her husband, Nicholas, was lost at sea in 1892. She called it Laurel Inn. The building stands today. This view looks south. (June Sabin.)

Edward Cheever lived on a homestead on Langlois Hill in 1888 and walked to town to work as a carpenter. After his house burned in 1900, he built this house and general merchandise store just north of town. Later he operated a hardware store in other buildings in town. The people in this photograph are unidentified. (PMC.)

Harve Smith leads cattle through Langlois in the early 1900s. About once a year, cattle were driven from Crescent City, California, north to Myrtle Point to the railroad or all the way through the mountains to Roseburg. People living along the way had to keep cattle out of their yards. The Cheever store and part of attached house are on the left. Occasionally hog drives were held. (PMC.)

The Pioneer Hotel in 1909 was owned by Leah ("Dolly") White and managed by her sons, Jim and Jake. In 1900, Danish Jens Sorensen and his wife, Marie, had come to Langlois and farmed; at some point they operated this hotel, which included barbershops, a poolroom, and a blacksmith shop. (Curry Historical Society.)

In this 1908 view, the Pioneer Hotel can be seen down the street at the left of the picture. The store nearest the right edge is Rackleff's General Merchandise. In 1910, a fire burned the hotel, these buildings, and several more, but not all of Langlois. Edward Rackleff was postmaster at the time, and the post office was inside the store. (Curry Historical Society.)

In 1907, two men from out of the area vacationed at Floras Lake and decided the beautiful area needed to be promoted and that they could make some money. Within a short time they had laid out lots and advertised around the United States for people to invest their money in the new community of Lakeport. This is one house that was completed. The population grew to about 400 people. (PMC.)

The centerpiece of Lakeport was this fine hotel (1908) with comfortable and attractive rooms, a dining area, and other amenities. There were also stores, a newspaper office, a school, and other facilities. The main attraction was the promise that a channel would be dug from Floras Lake through the sand dune to the ocean. Ships would be able to come into a sheltered harbor, and a great port would develop. (PMC.)

These unidentified men were the survey team for Lakeport. They camped behind the Langlois Tavern. While the community lasted about eight years, Langlois benefited. Dairy products sold well, and the businesses in town profited. The beginning of the end came when the engineering results showed that the lake was higher than the ocean; digging a channel would drain the lake. Investors lost their money. (PMC.)

The Langlois community band is posing in the early 1900s (before 1908). From left to right are (first row) Lex Cope, Bill Guerin, Bill Cope, Ralph Cope, and Walter Sabin; (second row) Allen Boice, Ben Cope, Ross Whitman, George Stewart (bandmaster), Gent Russell, Hans Clausen, and Bill Hawkins. The band played for parades and other community events. (Curry Historical Society.)

James Sylvester Capps's home stands at the top of the rise (right) in early Denmark, Oregon, about 1910. J. S. Capps raised sheep and cattle on his farm and was a schoolteacher and postmaster. Capps constructed and operated a general merchandise store in the building just to the left of the residence; it was operated by Kay Nodine for several years. (PMC.)

At left, around 1910, is McMullen's store; beyond and out of sight are the Thrift/Langlois store and livery stable. On the right, from front to back, are the telephone office, Cheever-Bowman Hardware, and the rooming house, operated by Mary Sorensen and others over the years. Dances and basketball games were held on the second floor of the hardware store. This view looks north. (PMC.)

Seen in this building to the right in this *c.* 1912 image are Edgar Thrift's General Merchandise Store and the Langlois Post Office. Thrift, the son of A. H. Thrift, purchased stock saved from the Rackleff store and rebuilt the store after the 1910 fire. Next is a livery stable, confectionery, Hotel Langlois, and the Allen Boice home to the far left. The confectionery building housed Langlois's first elementary school. (Curry Historical Society.)

This large Woodmen of the World building (Dairyville Camp No. 575) still stands at the south edge of Langlois. This road, shown around 1914 was the Langlois Wagon Road. The Woodmen stayed in Langlois until the 1920s, conducting lodge meetings and sponsoring dances and other community events. The building was later used as a grocery store, telephone office, clothing store, and temporary school and today is an art gallery. (POHS, Thrift collection.)

About 1911, after the town fire, the Hotel Langlois was constructed and was in business for some years. Mary Sorensen, daughter of Jens and Marie, managed it for a time. Wallace Pomeroy and Clyde Corrick owned it and later operated it as Cheever Hardware. The building still stands in Langlois and was most recently an antique store. It is now vacant. (PMC.)

This was Heckel's Shell Service Station north of Langlois around 1912. It appears that the horse is about to tow the truck, though the photograph by C. David Barklow might have been a joke. Both modes of transportation were still used in north Curry County at that time. (Curry Historical Society.)

This early Langlois or Denmark cheese factory is accepting milk deliveries from nearby farms. From left to right are Milt Brown, Hazel Manning, Lee Brown, and cheese-maker Manning. According to Emil Peterson and Alfred Powers (A *Century of Coos and Curry*), a few creameries were built in Curry County beginning about 1893. (Curry Historical Society.)

McMullen cheese factory about 1913 was north of Denmark Cemetery. From left to right are (on roof) John and Louis Kreutzer, John McMullen, and John Capps; (standing, center) is Adoph Ignisweller; (on loading platform) unidentified, Frank McMullen, Ike Cox, George Chenoweth, and unidentified; and (in background) Nel Swanson and Bill Chenoweth. The boy beside horse at right is probably Charlie Jensen, age 12, who was paid 10¢ a day to deliver milk. (PMC.)

The Charles Zumwalt family at Sixes operated a dairy farm and cheese factory for several years. In 1943, Swift and Company owned the factory, using milk from 20 or more farms. The larger dairies each produced 100 or more cans daily in May and June, the peak months. Swift used high-quality equipment and met state health department standards. Manpower was scarce during the war, so several women worked in the factory. In the photograph below are members of the management team. They are, from left to right, Wes Zumwalt, manager; Ralph Hall, cheese maker; Keith Miller; Joe Hayward; Crissy Miller; and Bea Zumwalt. Not pictured is Neonta Hall. The factory later burned, as did the Swift-provided house where the Zumwalts lived. Stanley Quigley was an earlier cheese maker at the factory. Charles Zumwalt held county and local offices. (Both, PMC; below, photograph by Neonta Hall.)

Danish Hans Hansen came to Langlois and, in 1915, leased the Star Ranch and milked about 150 cows per day. From 1925, he made Langlois Blue Star cheddar cheese. The above photograph was taken about 1938. In 1940, Hansen and Verner Nielsen from Iowa State College developed a blue-veined cheese, modeled after France's Roquefort, but made of Jersey cow milk. In the below photograph, the new building is being constructed for making blue cheese. Rich, golden Langlois blue cheese sold well, much of it through mail orders, until a 1957 fire ended the factory and the business. (Both, PMC.)

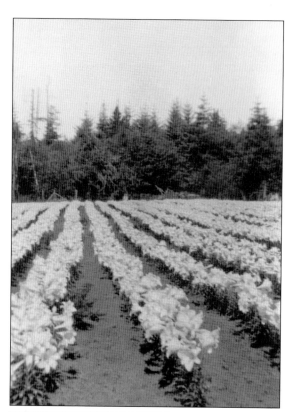

Croft Easter lilies were widely grown in the area in the 1940s and 1950s. Some growers were Art Strain, Jake and Jim White, C. T. Guerin, Louis Knapp, A. A. Cline, George Guerin, Clark Slocum, Walter Hofsess, Joe Cox, and Everett Isenhart. Jim White named his new variety "Nellie R. White" in honor of his wife; Slocum developed a variety called "Ace." Others at Sixes and Port Orford grew lilies. (PMC.)

North Curry County dairy farms produced record-setting Jersey cows. Sidney Cadman had one such champion. In the 1940s, Opal Crystal Lady, owned by Ralph E. Cope Jr., held four national championships by age seven, and in the 1950s, Tristram Basil Pearl (shown below), owned by A. W. Sweet on the Elk River, produced over 80 pounds of milk a day (twice-daily milking) with high butterfat content. (PMC.)

Four

GROWING PAINS
1900–1929

The *Port Orford News*, Volume 1, No. 1, appeared November 9, 1926. Editor George W. Soranson printed a front-page announcement to the public, which praised the coastal beauty, climate, and natural resources of timber, minerals, and fish. He predicted a prosperous future for the region. He included the Roosevelt Highway (a reality) in his vision, as well as a railroad (an elusive dream). Soranson said his newspaper "foresees a happy and contented people, as no one can live within such environments without being contented, and the mild ocean atmosphere, if not a cure-all, is a panacea for many of the ills that affect mankind."

Such was the generally optimistic mood of the United States in the decade between World War I and the economic crash of 1929. Port Orford was growing slowly, always dealing with its relative isolation from population centers, fluctuations in timber and gold markets, difficulties of maintaining facilities in the harbor, and the daily work of living in a beautiful area where warm, sunny days alternated with rainy days and brutal storms. Residents found ways to stage events and have fun as well.

Conveniences were gradually added to make life easier: the automobile, telephone, and electricity. Automobiles were seen more often in Curry County after World War I ended in 1918. Major influences on the south coast, as elsewhere, were the dark days of the war, followed by the influenza epidemic, and the Roaring Twenties.

At the southeast edge of Port Orford in the early 1900s, bare snags remain from the 1868 forest fire. The Knapp Hotel is at top center. Next to the street, lower center, is a barn belonging to the Masterson House with a water tower on the roof, the roof visible just beyond and slightly left. Between the barn and house is a boardinghouse operated by the Mastersons. (Curry Historical Society.)

Around 1900, Allen Boice used a six-horse team to haul freight to and from Bandon. A frequent load was salmon from the Sixes River. Sometimes they sold fish to farmers along the route. Jim Chenoweth is driving Boice's team. Allen Boice drives Chenoweth's team, in the rear. Allen Boice held several other jobs, including that of county commissioner for 18 years. (PMC.)

These people enjoy a Fourth of July midnight supper in 1903 at the Knapp Hotel after dancing. The hotel often hosted social events attended by local people and out-of-town guests. A famous person who stayed in the earlier hotel was William Seward, secretary of state under Andrew Johnson, who stopped in Port Orford in 1867, both coming and going to Alaska to purchase it from Russia. (Mike Knapp.)

Three keepers are taking a break from cleaning at Cape Blanco Lighthouse in 1905. On the left (with duster) is James Hughes, first assistant, who served 38 years at the lighthouse, and at center is James Langlois, head keeper, who served for 42 years. On the right (with broom) is Otto Heins, second assistant. Langlois was a son of William V. Langlois. When Langlois retired, Hughes became head keeper. (POHS, William Leep.)

The *Port Orford Tribune* from May 11, 1910, carried the following advertisement: "Keep your money in Curry County. The bank of Port Orford is now ready and its facilities are up to date and complete in every detail of both equipment and service to transact the banking business." Louis Knapp was president of this first bank in Curry County; it is not known how long it lasted. (PMC.)

Ames Johnston built this house in 1910 for family use. From the 1920s to 1940s, it served as a hospital. At least one current resident of Port Orford was born there; others remember receiving treatment. In the late 1930s, Nick Marsh bought it for his family. It served as an antique store *around* 1970 and now houses the office for Camp Blanco RV Park at the north end of town. (PMC.)

During the early 1900s, Port Orford held the Agate Carnival each August. For some years it was held at Agate Beach, a popular camping and picnic area, now known as Tseriadun State Recreation Site. Local men cut a road through the forest from town to the site and built a wooden floor under a huge tent for dances and wrestling matches. The picnic pictured here was held in 1913. (Curry Historical Society.)

Wrestling was popular at the Agate Carnival. Myron Lutsey (in black shirt), a local cheese maker and wrestling champion, told the 1913 crowd he could pin all these men in one hour. Those pinned—in half an hour—are, from left to right, (seated) Andy Spurgeon, Sam Hayes, and Lester White; (standing) Percy Zumwalt, George Sutton, Bud Post, challenger Lutsey, Gene White, Bob Perry, Clarence Wright, and Raymond Standard. (PMC.)

The Knapp Hotel shown about 1909 is at lower left with stables nearest the bottom, the George Forty house built around 1901 is in the center, and the 1876 Centennial Building is in the upper center, behind it. The tall white building at the right had a garage on the ground floor. The Forty house was moved at least twice and remodeled; it still stands. (PMC.)

Port Orford —13

—WHEELER—

This view looks north on Jackson Street, the main route through Port Orford in 1913. At left, from front to back along the street, are the Winsor Hotel, Masterson House, Gillings Hardware, Charlie Long's grocery, and Nygren Hotel. Visible on the horizon is a large rock called Silver Butte. It is now shorter, as part of it was later blasted away to get rock for construction purposes. (Alan Mitchell.)

Robert McKenzie, in the driver's seat, was born in Scotland, lived in Australia, and came to Port Orford in the 1870s. He lived with his family on a dairy farm near the mouth of Elk River. His wife, Georgina, sits beside him. Henry Adolphsen (left) and Bob McKenzie stand behind the car; in the back seat, from left to right, are Eliza McKenzie, Louise Scofield, Florence McKenzie, and unidentified in this *c.* 1911 image. (Shirley McKenzie Van Loo, descendant.)

The Port Orford Band in 1916 included, from left to right, the following musicians: (first row) Louis Knapp, Leland White, Johnnie Stone, and Zack Zumwalt; (second row) Wes Zumwalt, Lynn Woodcock, Dad Buffman, Andrew Spurgeon, N. H. Larson, and Bernal Forty; (third row) Clive Davidson, Merle Woodcock, J. C. Mock, Lowell Johnson, Delmar Wright, N. F. Woodcock, Herbert Unican, and Gene White. (Curry Historical Society.)

In the early 1900s, a large, carefully engineered structure stood on Fort Point at the south edge of town that was used to move logs and lumber directly down to the water below the point. This avoided both the uncertainty of using the dock, which sometimes washed away in a storm, or paying a fee at the dock. A theory is that logs or lumber were lifted and carried on the long track, then lowered over the point by a cable—connected to a huge rock—to the beach and water below, and finally, loaded onto waiting ships. This was possibly the apparatus built by the Pacific Furniture and Lumber Company, which was mentioned by Pat Masterson in his book. The above photograph shows part of the superstructure; the one below shows the interior of the engine room. Both views are dated 1917. (Both, Dixie Tucker.)

This 1916 view of Port Orford looks west. The log-loading tramway is clearly visible with the icehouse for fish just past the lower end. The Knapp Hotel is in the right foreground. (PMC.)

In the early 1920s, the Gillings Hardware Store was an important business. Both John and his wife, Mabel, who arrived in Port Orford in 1910, were active in the community. Mabel started a traveling library by frequently going to the state library in Salem (about 250 miles) and borrowing books, which she would then bring back, distribute, re-collect, and return. John served on the Port Commission. (PMC.)

Several buildings are prominent in this 1921 panoramic view of Port Orford. At the center of page 60 is Fort Point with the log-loading structure. Battle Rock is at the far left. The SS *Elma* is visible at the dock. Down the hill from Fort Point is the Winsor Hotel with the tall Leneve Building to the left of that. Moving north up Jackson Street from the Winsor Hotel are the Masterson House

(with a boardinghouse at right, barn, and water tower), Gillings Hardware Store, Long Grocery, Lindberg Garage, Stewart house, and Nygren Hotel. Across the street from the Stewart house is an early school building. Just right of the crease is the Episcopal Church. The Larson sawmill can be seen at center right as well as the two-story school building at far right. (Alan Mitchell.)

Seen about 1913 at the south end of Port Orford is the Knapp Hotel at the far right with the George Forty house to its left. The highest roof at the far left is the Leneve Building. The next large structure to the right is the two-story white building, which housed a garage on the first floor. (Curry Historical Society.)

The three-mast schooner *Joan of Arc* wrecked November 15, 1920. Lumber salvaged from the ship was used to construct several buildings, including the one pictured here around 1980, which was constructed in 1921. Bob Forty (a logger and son of George Forty), his wife, and two daughters lived there. Since then, the Forty house has been a restaurant, a bed and breakfast inn, and is now a vacation rental called the "Joan of Arc." (PMC.)

Edward Lindberg, son of P. J. Lindberg, operated a garage in this building during the 1920s. The barrel at left held water for submerging damaged tire inner tubes to detect leaks. Note the gasoline pump beside the door to the right of where Lindberg stands. The garage faced Jackson Street, then the main route through town. Lindberg's daughter Lucile was born in the adjacent house. (PMC, Lucile Lindberg Douglas.)

In 1924, former residents of Port Orford returned for a Pioneers' Reunion. Activities took place in this tent. The Honorable Binger Hermann, Coos County pioneer and former U.S. congressman from Coos and Curry Counties, gave a major speech; music and dance were performed; and an outdoor evening reenactment of the 1851 fighting at Battle Rock was held. The total crowd was estimated at 3,000. (Curry Historical Society.)

Paul Leutwyler came from Switzerland to Port Orford in 1923 to join his blacksmithing brother, Rudolph. In the late 1920s, Paul bought his brother's business interest and married Agnes "Aggie" Miller, a widow with one son, Lawrence. Paul shod horses and worked on Model T Fords. The original Battle Rock Garage building later housed a restaurant, duck pins bowling alley, candle shop, and was recently renovated to be a fine art gallery. The original ceiling is still visible. A talented mechanic, Paul Leutwyler, had the first electricity in Port Orford, which was produced with a generator he built. In the c. 1930 photograph below, he is working inside his shop. His work kept people moving by horse and then automobile. He was in business nearly 50 years, longer than any other person in the history of Port Orford. (Both, PMC.)

During World War I, 1914–1918, West Coast residents were nervous about the possibility of German submarines in the area. There was talk of a (Theodore) Roosevelt Military Highway for transporting troops and equipment along the coasts of Oregon and Washington. The highway was not built during the war, but was needed afterward for civilian use. Responsibility for such a highway fell to states and counties with some federal help. Oregon voters approved the project in 1919. Starting in 1921, the road was constructed in sections, beginning at the north end of the Oregon coast. Later in the decade it came to Curry County. The c. 1927 photograph above is in the Humbug Mountain area. The view below, from about 1928, shows a car having just crossed Hubbard Creek Bridge south of Port Orford. (Both, PMC.)

This *c.* 1924 motel was clean, modern, and up to date for its time. Conveniently located on the Roosevelt Highway route, it attracted weary travelers looking for a place to spend the night. The remodeled motel, now the Port Orford Inn, still stands beside the highway, which is now paved. Several different restaurants have occupied the front right portion at different times. (Stephen Thompson collection.)

An auto stage stops in Port Orford at the McPhillamy house around 1926. Before Greyhound bus lines, at least as early as 1924, this bus and others like it traveled the new Roosevelt Highway, connecting with other stages to take travelers to Washington, California, and elsewhere. The building behind the stage is one of the oldest in Port Orford. Part of it is incorporated in a restaurant. (Alan Mitchell.)

Standing in front of the Knapp Hotel about 1924 are, from left to right, Louis Knapp Sr., Mrs. Holt, Binger Hermann, Tom Langlois, and Mrs. George Guerin, all of whom were influential in north Curry County. They represent pioneer families of Coos and north Curry Counties. Knapp was builder and owner of the hotel for six decades; Hermann was a congressman. (Alan Mitchell.)

In the early 1900s, cars were still new and living horsepower still dependable. On a road near Port Orford about 1928, both kinds of transportation are seen in use. The dual modes were common for several years; both blacksmith shops and service stations did business, sometimes on the same premises. (PMC.)

Sixes Post Office was in different locations at different times. This one, in the early 1900s, was at least the second building. It was constructed on stilts because of river flooding and was on the east side of the highway facing west. The woman at left is Liea ("Grandma") Wells, postmistress, and the other woman is Annie Wells. Often the same family operated the store and the post office. (PMC.)

The Wells family owned the first Sixes Store and blacksmith shop. They ran a small inn where mule train drivers ate on their way to upriver mines, 12 miles by road and trail. In 1929, the C. C. Woodworth bought the store. It burned in 1941, was rebuilt, and purchased by Harry and Ray Helmken. It was open and selling meals into the 21st century. (PMC.)

Five

A MARITIME COMMUNITY

The founders of three north Curry County communities were all characterized as being seafaring adventurers: Capt. William Tichenor, Port Orford; Capt. Nicholas Lorentzen, Denmark; and William Langlois, Dairyville, later called Langlois.

Port Orford's first settlers arrived by sea. People, their luggage, and other freight continued to be transported by sea throughout the 19th century. From the earliest days, the settlers used the bounty of the sea for food. Crab and several varieties of fish appeared often on local tables. Clams could be dug at some beaches. Sea lions were hunted for their oil and skin; their hides sold well, because they could be made into excellent leather belts and other goods.

Shipwrecks brought different bounty. While several wrecks occurred close to shore and people on the ships were rescued, large amounts of lumber, foodstuffs, and other objects washed ashore. A lighthouse was established at Cape Blanco in 1870 and a U.S. Coast Guard Lifeboat Station on the Port Orford Heads in 1934. Commercial fishing started in the 20th century and is still a significant part of the local economy.

In the 1880s, people campaigned to make Port Orford a "Harbor of Refuge," where ships could safely wait out a storm. That would have required building an expensive breakwater. The project was approved, but Congress wanted less cost, resulting in the plan being postponed and never enacted.

In 1911, voters created a Port District, and so a Port Commission was elected. The Oregon attorney general declared such a district illegal, as Port Orford was not on a bay or river; in 1914, the next attorney general changed the ruling. In 1919, the commission reorganized, and the first bonds were issued for a new dock, built in 1920. There were a few good years of shipping lumber by sea.

The commission pressed for federal help again. A 1924 bill in Congress authorized a harbor survey. In May 1926, the Corps of Engineers visited and later rejected the local proposal for expansion.

Docks and jetties were built, deteriorated, or destroyed by storms and built again.

Seen here about 1930, Hubbard Creek flows into the ocean 1 mile south of Port Orford. It was down this waterway and out to an offshore rock that lumber was transported from a large mill to lighters and then to ships. The bridge is part of the coast highway; Hubbard Creek is the largest creek near Port Orford and today supplies the city's water. (Alan Mitchell.)

Garrison Lake (or Garrison Lagoon) was labeled Port Orford Lagoon for this c. 1930 photograph. The only barrier between fresh water and the ocean is a sand dune, which can be diminished or overtopped during storms, making the water salty. Fishing, swimming, canoeing, and bird watching have been popular here, and the lake has served as a secondary source of city water. (Alan Mitchell.)

Early settlers arrived without a dock, but the first one was soon built. The army post at Fort Orford needed a place to unload materials and troops; settlers wanted a dock for fishing. Port Orford has built and maintained a succession of docks through the years. This is a very early dock in the late 1800s. (Alan Mitchell.)

The huge boiler, unloaded at the dock, will be pulled by the oxen to Asmus Adolphsen's Elk River sawmill. Adolphsen stands near the oxen; Bob Forty is on top of the boiler. The men at the end of the boiler are Mike Linvall (left) and Henry Adolphsen (right). Pehr Johan Lindberg built the bridge leading to the dock around 1888, after that part of the previous dock washed out. (POHS.)

The date on the back of the photograph above is 1914, and the automobiles reflect that date. This could be a new dock built in 1914. In spite of being ignored by the federal government, local people had high hopes of creating a world-class port. In 1920, the new Port Commission ordered a dock constructed at a cost of $35,000, not including the approach from shore. Additions were made in 1921 with the help of Bandon's Moore Mill and the Port Orford Mill Company. In 1922, the approximate date of the view below, the commission approved another addition. (Both, PMC.)

In 1923, the Port Commission contracted for another extension, making the dock 140 feet at its widest point and 502 feet long, including the approach. The berthing space was 300 feet long. The Norwegian (some say Swedish) steamship SS *Frogner* called twice, loading logs and lumber. At 400-plus feet long, 52 feet wide, and 9,300 tons displacement, she was the largest ship ever to visit Port Orford. In 1923, local authorities declared that 10 million feet of Port Orford Cedar, alone, was shipped from the dock. (Both, Alan Mitchell.)

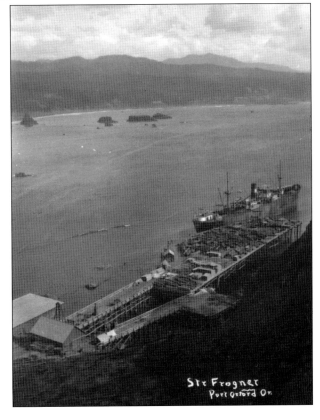

Str Frogner
Port Orford Or.

After much negotiation, a U.S. Coast Guard Lifeboat Station was established in 1934 on the high point known as Port Orford Heads. The photograph shows the barracks structure where crewmen lived and ate their meals. The building also contained an office. Visible through the porch at the right of the building is a corner of the home for the officer-in-charge. The station was decommissioned in 1970. (PMC.)

C 13 465 - Nellie's Cove and Port Orford Head, Oregon Coast Highway.

Nellie's Cove lies at the foot of Port Orford Heads on the eastern side. Said to be named for Captain Tichenor's daughter, Sarah Ellen, the beautiful area is somewhat sheltered from the wind and provided a good place for launching small boats. This picture was taken before the lifeboat station was built. (PMC.)

Two boats were stored in the Nellie's Cove boathouse, one a powerboat and the other manual. The two tracks converged to become one on the lower portion of the ramp, behind the rock. The concrete breakwater, installed to protect the lifeboats as they left or entered the cove, is prominent in the photograph. In the upper-right section of the photograph, roughly half of the 500 steps leading from the barracks down to the boathouse can be seen. Some steps were made of concrete, but most were wooden. In answering a distress call from a ship at sea, the men descended the steps as quickly as they were able and launched a boat. Returning from a mission, they returned the boat(s) to the boathouse and climbed the steps. The boathouse was destroyed in a 1939 storm and rebuilt. Oregon State College used it for research in the 1970s. The building burned—probably by arson—in the late 1970s. (Laura Eades.)

This lookout tower stood during the years the station was active, 1934–1970. The 37-foot structure at the far southern tip of the headland was used by crewmen to scan the coastal area to the west, north, and south. If a distress signal was observed, they went into action for search and rescue. During World War II, the tower was used to watch for enemy aircraft. (PMC.)

"Little America" was the name given to a residential area for coast guard personnel and their families. Coast guard houses were built individually; some are still occupied today, and several other houses have been built in the area as well. At the top of the Heads on the north side, there are views of the ocean to the west and Garrison Lake to the north. (POHS.)

In 1923, lumber shipping peaked: 61 steamers called, delivering 1,085 tons of freight and loading 35,585 tons of logs, lumber, and freight. Then business declined, and a 1927 petition by taxpayers asked the Port Commission to sell the property. In 1934, Gilbert Gable bought it. Gable had bought the Inman Mining Company in the early 1930s and had access to their plans to obtain rock from Graveyard Point—said to be named because some unmarked graves of soldiers were there. He implemented the plans as shown above. About 70,000 tons of rock were reportedly removed and used as the base of a new dock and breakwater, shown below. Gable, whose work will be described more completely in the next chapter, attracted national attention for this project. He arranged for an open telephone line to New York City, where some of his financial backers were located, so that they could hear the sound of the blast. The dock was built over and beside the massive chunks of rock from the point. The ship is the *Shasta*. (Both, PMC.)

A gala celebration was held on Labor Day 1935 at the new dock. The speaker was then governor of Oregon Charles Martin. Dignitaries, including Gilbert Gable (at the near end of the row), are seated. A band is partially visible at right. The festivities went beyond dedicating and bragging about the new dock. Social activity came later, including a reception for the governor and a marine pageant. (Alan Mitchell.)

Celebrants might not have been so enthusiastic if they had known that less than five months later the worst storm in 40 years would destroy the dock and breakwater. A replacement was built and is shown in this 1938 view. The dock is larger than Gable's and is stacked with lumber. In 1941, Ed Kaakannin of Westport, Washington, bought the dock and operated a cannery for 15 years. (PMC.)

At some point, fishermen began berthing their boats on the dock or the area adjacent to it, as shown in this view in the late 1940s. The derricks are for raising and lowering the boats. By this time, the focus of harbor activities was on harvesting seafood rather than shipping lumber, which was usually done by truck. (POHS.)

In 1956, the present Port District was formed. The district bought back the deteriorating facility and repaired it as shown in this 1959 view. Lumber was shipped again until February 9, 1960. A major storm with winds over 100 miles per hour destroyed the dock, setting more than 1 million feet of lumber adrift. (PMC.)

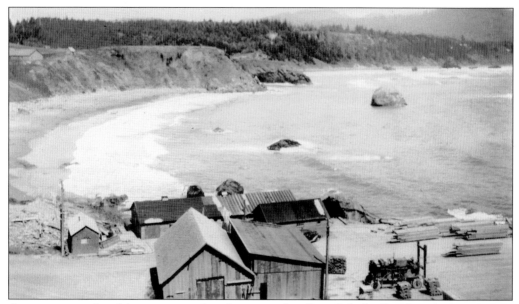

A cannery or other fish processing plant has existed in Port Orford off and on for many years, under various ownerships. This one is dated 1938. Dungeness crab, shrimp, and salmon have been harvested and canned at different times. In the upper-left corner is a building that was an icehouse for keeping fish. In the 1920s and 1930s, a cannery was located there. (PMC.)

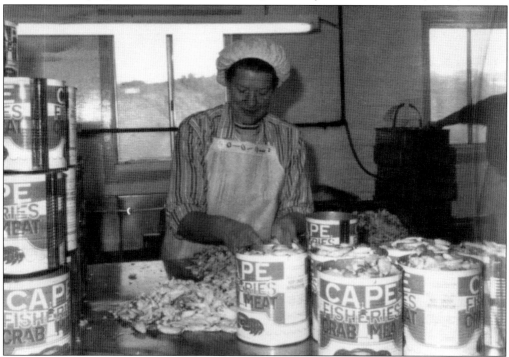

Winnie Edwards works in the cannery in the early 1970s. A pile of crabmeat is at her fingertips for filling the 5-pound cans for restaurant trade. At the top of each can of meat the women formed a flower design with chunks of crab-leg meat before the can was sealed. As many as 60 people at a time worked in the cannery. (Myrtle Clark.)

The 1975 picture below shows the timber pile dock in use from the 1960s until it was replaced in 2000. At far right is the cannery building constructed about 1940; though no longer a cannery, it stands today in bad condition. Fishing boats are just beyond the building. Behind the dock at left is the jetty constructed by the U.S. Army Corps of Engineers in 1968. Though protecting the dock, the jetty causes sand to accumulate on this side of the dock, making it difficult for fishing boats to get in and out at low tide. The only remedy has been dredging, which is expensive and not always available. At right, a fishing boat is lowered on to its trailer after being hoisted from the water (pre-2000). (Right, PMC; below, Alan Mitchell/photograph by Robert E. Gable.)

14-985 Wreck of the

On March 9, 1936, the SS *Phyllis* traveled north from San Francisco. She had encountered much rough water and struck rocks off the beach near Humbug Mountain. All the crewmen were rescued and the cargo—a large quantity of canned food—was salvaged. The labels washed off before the cans could be retrieved from the beach; they were sold cheaply, with contents to be discovered when cans were opened. (PMC.)

"Cottoneva" wreck - Port Orford - Oregon 459 Sands

The coast guard rescued everyone on the SS *Phyllis* and also those on the SS *Cottoneva* on February 10, 1937. The latter was at the dock loading lumber when strong winds struck the area. The captain tried to leave but could not control the ship. After hitting a sunken object, he ran the ship onto the beach to save the crew. All 27, including the captain, were rescued by breeches buoy. (PMC.)

Six

DEPRESSION AND WAR
1930–1945

Two major influences on Port Orford in the years between 1930 and 1945 were Gilbert Gable and World War II. In spite of the Great Depression, the town's population increased dramatically between 1934 and 1936, largely because of Gable's enterprises.

Gable had made several trips to the area to check things out before he actually moved there in 1935. During his time there he crisscrossed the continent, returning to familiar places on the East Coast where he could talk to people with money and then influence them to help promote his interests. He borrowed heavily and lost heavily when the best-laid plans failed.

When he could get neither government nor railroad company support for his proposed railroad, he was discouraged. The roads for automobile and truck traffic were not in the best conditions, even though the coast highway had been "completed." Gable and others started promoting the secession of Curry County from Oregon to form the "State of Jefferson." He had support from northern California counties as well. Those in the north of that long state felt as distant and alienated from Sacramento as some southern Oregonians did from Salem. The rebels theorized that if a capital were closer—say, in northern California—they would get more attention for projects.

The campaign was in high gear and a provisional governor had been elected when Gilbert Gable died December 2, 1941. Five days later, Pearl Harbor brought the nation into war. Forest Service fire lookouts had the extra job of watching for possible enemy airplanes. The lookouts were alert and helped avert serious damage when the I-25 plane dropped fire bombs in two locations in Curry County, one just northeast of Port Orford. (This was the only attack on the U.S. mainland by military aircraft.) The local coast guard went into military mode with more personnel and increased security. Gable's vacant administration building was used by the coast guard, and dogs were kept in kennels behind the building. Men and dogs patrolled the beaches at night when they were off-limits to civilians.

The Roosevelt Highway was officially changed to Oregon Coast Highway in 1931 and declared "finished" when the bridge across Rogue River at Gold Beach, 25 miles south of Port Orford, was opened in May 1932. Some of the route was paved by then, but five more bridges were not finished until 1936. Still, the through route was a great boost for the economy and for people's morale. The route was later named U.S. Highway 101. The above photograph shows automobiles returning northward through Port Orford after the grand opening of the bridge. Visible buildings are the hotel and market opened by Willis and Susie White in the 1920s, Leneve's Drug Store, and a garage. The photograph below shows a segment of highway south of Port Orford. (Above, Alan Mitchell; below, Stephen Thompson collection.)

In the 1920s, Susie Neer and Will White constructed the Western Hotel, Restaurant, General Store, and Meat Market, which they operated for several years. Beyond is the Leneve Building, housing a restaurant. Both structures still exist, though their exteriors look different. The dark gabled buildings at right burned in a fire around 1934. The white false-front building is Charlie Long's grocery store. (Lucile Lindberg Douglas.)

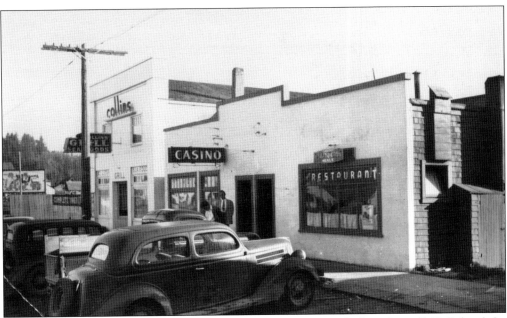

Two restaurants existed side by side at the south end of Port Orford in about 1940. Behind the billboard are the Knapp Hotel and the coast highway continuing east and south. Since 1955, Pitch's Tavern, originally owned by Mr. and Mrs. Otto Pitcher, has conducted business on the site of Collins Grill. (PMC.)

Administration Building on the day of the opening. The signal flags spell (Welcome P.O.D.T.). The corner room nearest is mine and is the bar in t

About 1935, Gilbert Gable and his wife, Paulina, came to town. Gable had worked in publicity, banking, exploration, motion pictures, and radio broadcasting. Through his program, "Highroads to Adventure," he learned about southern Oregon mining and made several trips there to see for himself. A man of big ideas and high energy, he started several companies and constructed this administration building to house records and business activities of those companies: Port Orford Dock and Terminal Corporation, Oregon Engineering Corporation, Trans-Pacific Lumber Corporation, Trans-Pacific Lumber Sales Corporation, Last Frontier Realty Corporation, and Gold Coast Railroad. The photograph below shows a fireplace in the reception area of the building. Seats were made from wooden water pipes used in hydraulic mining (see chapter 2). All that remains of the building today is the extension on the near end (right) and stone chimneys. (Both, PMC.)

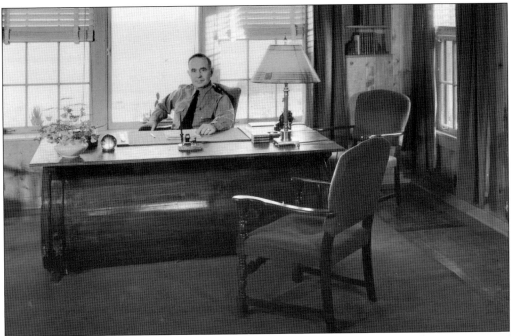

Seated at his desk, surrounded by a beautiful building, Gilbert Gable looks the part of a CEO of six interdependent companies financed mostly with borrowed money. He might not have spent a lot of time there, as he sometimes stayed at Camp Gable up the Sixes River when working with miners. He made frequent trips to the eastern United States to promote his projects and enlist support. (Alan Mitchell.)

Reeves Taylor was Gilbert Gable's valuable assistant. He served as treasurer of Trans-Pacific Lumber Corporation, vice president of the Last Frontier Realty Corporation, and all-around helper. He stands in front of the partially completed Trans-Pacific Lumber mill. Gable's tenure in Port Orford was not long, about seven years, but Taylor remained. He married, built a home, and continued to be active in the community. (PMC.)

In 1935, after the dock dedication, Gable led Port Orford to become Curry County's first incorporated city. Gable was elected mayor. The city council met at various locations, until Gable organized the building of a small wooden structure to contain city offices. In 1936, the jail—constructed of concrete—was added. A 1958 fire destroyed the wooden city buildings; the jail survived the fire and still stands unused. (PMC.)

Gilbert Gable, with the help of Doug Johnson, the town's second mayor, built these chairs of myrtlewood for the mayor and councilors. Myrtle is a kind of laurel tree that grows only on the southern Oregon and northern California coasts. It is hard with an attractive fine grain and varying color. The chairs were saved from the fire and are used today in the Port Orford City Council Chambers. (PMC.)

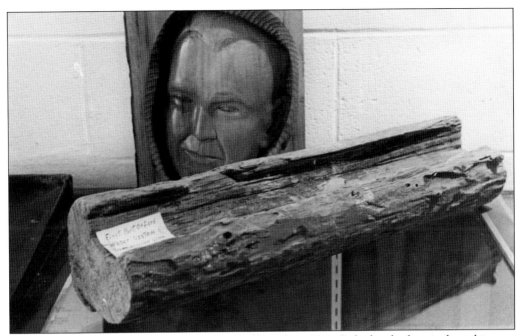

Port Orford's first water system was made of hollowed-out Port Orford cedar logs such as this one. The carved wooden face is Gable's; the piece of art carved from myrtlewood by Donald Babel of Seattle was donated to the city by his sister, Nadine McWilliams, in 1980. (PMC.)

In the late 1930s, the Centennial Building at the corner of Sixth (U.S. Highway 101) and Jefferson Streets offered food, souvenirs, and sports equipment. Constructed the year of America's centennial, the building was demolished in 1976, the year of the bicentennial. The Centennial Building housed Katie's Café, a cigar store, and other businesses at different times. To the right are the first Leutwyler Garage building and Vi's Café. (PMC.)

Heinie Dolge opened a service station and garage in the long white building at the rear of this picture in 1937. In the foreground, about 1940, is Hurst's service station. The two young men are Delbert (left) and Leo Woomer. The Dolge building, below, was renovated and expanded by Bob and Vicki Courtright for their Art Hatchery, which they owned for 15 years in the 1970s and 1980s. The building has been occupied by the Downtown Fun Zone since 1991. The Downtown Fun Zone rents videos and DVDs, sells paper and computer office supplies, and publishes a free weekly newspaper. A picture frame shop and natural foods store share the building. The exterior no longer has a southwestern look but has wooden siding. (Above, Lucile Lindberg Douglas; below, PMC.)

Paul Leutwyler had a new building constructed for his garage and moved into it in 1940. It retained the name Battle Rock Garage for the rest of its life, though it was nine blocks away from the rock. A dance was held in the new building as part of opening festivities. Longtime employee Bill Foster assumed management of the garage when Leutwyler retired. The business closed in 2003. (Alan Mitchell.)

At Battle Rock Wayside in the late 1940s, tourists view the coastline from their cars. The largest rock at right center is still called "Mill Rock," "Dock Rock," "Wharf Rock," "Stair Rock," or "Lumber Rock." It was the terminus of a tramway from a mill on Hubbard Creek, just behind the tall rock in the center of the picture. The tramway was destroyed by a storm. (Alan Mitchell.)

Quick's Market, around 1940, served Port Orford for about eight years. Other grocery stores occupied the same building, which eventually burned. Mrs. Quick was Ellen Tichenor, a great-granddaughter of Capt. William Tichenor. Her son John Quick, a great-great-grandson of the captain, wrote a book, *Fool's Hill*, in his later years about his memories of living in Port Orford as a young child. (PMC.)

Directly above the Knapp Hotel, about 1939, is the 1876 Centennial Building; tenants then were dentist Dr. R. Pugh and his pharmacist wife, Mary. At lower left is a restroom for Battle Rock State Wayside. Carroll Tichenor, William's grandson, constructed the house above (sloping roof) and rented it out; a later addition contained a popular souvenir shop, the Shell Shack. Gilbert Gable's administration building is left, up the hill. (Alan Mitchell.)

Gable planned a railroad to come 90 miles from the Rogue Valley east of the Coast Range, down the Rogue River, up a creek valley, and into Port Orford, ending at the dock. The "Gold Coast" line would connect seagoing traffic with the railroad network inland. Gable tried hard to make the railroad a reality. In 1935, his application was granted a "certificate of convenience and necessity" by the Interstate Commerce Commission (ICC). After the dock collapsed in early 1936 and no construction had been started, a rival group applied for a similar line terminating in Crescent City, California. When Gable and the rivals appeared before the ICC, the body withdrew its earlier support of Gable and refused the Crescent City application. To this day there is no railroad in Curry County. (Both, PMC.)

M-358 Greyhound Bus Stop - G.W. Needham - Langlois, Oregon

Needham's Texaco Service at Langlois was a regular stop on Greyhound bus lines' coastal route. In 1940, two buses came through the area daily, each way. In the late 1940s, Val and Jack Whalen purchased the station and added a restaurant. Gas tanks were removed in 1952; the main building burned in the 1980s. Langlois Public Library occupies the location; Greyhound no longer serves the Oregon coast. (Curry Historical Society.)

Young people left Port Orford to fight in World War II after the Japanese bombed Hawaii in December 1941. The war seemed remote until 1942, when this aircraft, launched from an I-5 submarine, dropped incendiary bombs in two places in Curry County, one close to Port Orford, intending to start forest fires. The same submarine sank the oil tanker *Larry Doheny* nearby. (PMC.)

Gathering scrap metal for the war effort in 1942 were American Legion members Monty Montgomery, Max Sauers, and Ray Babel. Mose Averill drove the truck. Other men are unidentified. The roofs of the Masterson House and boardinghouse are visible behind the stores. At far right is a house in which the first newspaper, *Port Orford Post*, was published for a time. (PMC.)

Oregon State Highway Commission purchased the Blacklock Sandstone Mining Company property in 1943 to create Newburgh State Park, named for the secretary of the defunct corporation. The U.S. Navy built an airport at the edge of the property. The mile-long runway was used by military planes during the war and is used by civilian aircraft now. The projecting land at lower center is Blacklock Point. (Photograph by Gary Percy.)

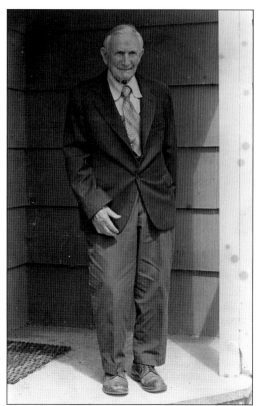

Louis Knapp, highly regarded citizen of Port Orford, was one of three sons of Louis Knapp Sr. After attending the University of Portland, he worked in family businesses: the hotel and the large Elk River farm. Knapp served on numerous local boards and was a state legislator from 1929 to 1933. He was a world traveler and spent time collecting and promoting local history. (PMC.)

In 1943, Louis bought the Thrift Ranch at Langlois. He remodeled the house and lived there several years while he raised cattle. The ranch had been owned by Thrift's oldest son, Edgar B.; the Grassley Brothers, who raised peas there for several years; George Laird and Associates; and again by the Thrift family. It is the Knapp Ranch today, owned by Mike Knapp, grandnephew of Louis Jr. (POHS.)

Seven

EDUCATION AND ENRICHMENT

Education, religion, fraternal groups, and social activities were important to people from earliest settlement. Oregon Territorial Legislature in 1854 passed a measure allowing six or more voters to form a school district.

Travel was difficult in wet months, so schools operated a few months of each year. Schools usually had one room, a wood stove for heating, drinking water in a bucket, and outdoor toilets.

By the late 1800s, schools had been located at Denmark, Elk River, Brush Creek south of Port Orford, Willow Creek near Langlois, Hare on Langlois Mountain, and Cape Blanco. A man named Russell, who lived far up Floras Creek, built a schoolhouse in his orchard and was clerk of the school for eight years. Other schools were New Lake, Round Grove, and Upper and Lower Sixes River; Dry Creek was the dividing line.

In her 1894 report, Emily Fitzhugh, Curry County School superintendent, noted 23 districts in the entire county and 16 teachers serving 370 students—north county schools were a portion of those. County superintendent Jennie M. B. Cope stated in 1926 that the new Roosevelt Highway was having a positive impact on schools. She also said, "In the last five and a half years six modern school buildings [in the whole county] have been erected."

One of those was "a standard four-year high school in Langlois." There was also a grade school. The first high school building was replaced in 1939. Two school structures and a gymnasium remain today, all empty. The brick building was used as a high school, then for seventh and eighth grades, then as an elementary school. The white building housed first through sixth grades, then seventh and eighth grades. In 1956–1957, the district joined with Port Orford School District to form District 2CJ. As population and school funding shifted, pupils were transported by bus between the two towns to make the best use of the facilities. With declining enrollment, all Langlois schools were closed in 2009.

From 1953 to 1962, Homer and Esther Millard operated a military preparatory high school on Langlois Mountain.

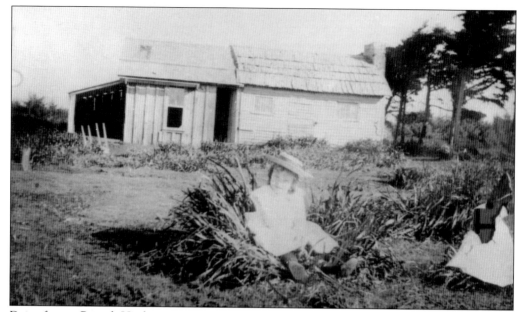

Dairy farmer Patrick Hughes was instrumental in starting the little school on windswept Cape Blanco in 1881 in District 15, though district lines were not exact. The students came mostly from the McKenzie, Langlois, and Hughes families. One teacher answered the annual report question on ventilation in the building by stating it was "extra good." The school closed in 1898, as other schools were established. (POHS.)

The date of this early Langlois school is unknown. This structure might appear typical, with white siding and a bell in a tower, but early school buildings were constructed in many styles, and rarely did two look alike. (Coos Historical and Maritime Museum, CHMM 960-60:1)

Attending Port Orford School in 1902 were, from left to right, (first row) Percy Zumwalt, Ray Zumwalt, Grace Kerr, George ?, Minnie Coy, J. P. ?, Bessie and Art Kerr, Mamie ?, Bernice Chandler, Edna Jensen, Charles Haines, Bill Nygren, Winnie Marsters, Clarence Zumwalt, and teacher Eva Hall Stewart; (second row) Hubert Unican, Elva Kerr, Rich Marsters, and Linda Sutton; (third row) R.G. ? , Dick Nygren, Florence McKenzie, Nora Nygren, Mary Sutton, Jim Sutton, and Jack Zumwalt. (PMC.)

This c. 1926 building is believed to be the one that served the Lower Sixes River area, located a short distance east of the main north/south route that became U.S. Highway 101. The two small buildings to the left of the main one are probably toilets. The presence of the bulldozer is unexplained. (Curry Historical Society.)

In 1913, a large school was built in Port Orford to house both grade and high schools. A bell tower and double stairway are on the east side of the school facing Jackson Street (see page 61). This view is the west side, facing what later became the highway. Local alumni remember dark, oiled wood floors, rows of desks, and other features typical of schools at the time. (PMC.)

Port Orford High School was built on the hill above the port in 1927. By all accounts, this was a beautiful, well-built structure in which students and the community took pride. It was constructed on the former site of Fort Orford (1851–1856). The gymnasium, to the right, was added later. This remained the high school until 1956, when it became Battle Rock Junior High School. (PMC, photograph by Wayne Thomas.)

The girls basketball team displays the "P" for Port Orford High School while posing outside the high school in about 1930. (PMC.)

The first-grade class of Port Orford is experiencing the first of many school pictures in 1933. (PMC.)

The Port Orford High School student body of 1938 included pioneer names such as Sutton, Jamieson, McKenzie, Lindberg, Sweet, Forty, and Lawrence Miller. The teacher was Ruth Clark who taught at the old high school, beginning in 1921. She continued to teach until 1944, when she was honored at a well-attended community celebration after she retired. (PMC.)

Stirring up something good in the home economics kitchen at Port Orford High School around 1945 are, from left to right, Kathy Helm, Gurlah Murphy, Evelyn Billings, teacher Vernice Masterson, Billie Jean Morris, and Dena Spencer. Masterson taught nine years at Port Orford High School, then five years at Pacific High. As well as home economics, she taught Latin, English, and math. (Pat Masterson, son of Vernice.)

These children graduated from the eighth grade at Port Orford in 1941. They are, from left to right, (first row) Thelma Jamieson, Rosemarie Sorenson, Dolores Marsh, Elene Haft, Doris Oxley, Mary Studley, Joan Thomas, and Shirley McKenzie; (second row) Lucille Tichenor, Orris Smith, Jack Masterson, Kenneth Fromm, Joe Hayward, Keith Miller, John Hatcher, and Doris Clark. The teacher was Mary B. Rice. (Curry Historical Society.)

The Port Orford High School class of 1941 is, from left to right, (first row) Tom Sorenson, Lila Glaze, June Hurst, Helen Holcomb, Mary Jane Raymond, and Wayne Newman; (second row) Gordon Forty, Cecil Jamieson, and Ralph Sweet. Local residents who graduated from the school on the hill fondly recall the flowers and greenery that decorated the hall for graduation. (Curry Historical Society.)

Dolores Marsh holds the ball; other members of the *c.* 1944 Port Orford High School girls basketball team are, from left to right, Donna Lou Marsh, Dorothy Hanna, Irene Ringhiemer, Buleah Lorentzen, Marie Swecker, Janice Jamieson, Mary Lou Morris, and Thelma Jamieson. (PMC, photography by Sands Photography.)

These young men made up the 1945 championship basketball team of Port Orford High School. They are, from left to right, (first row) Darryl Sauers, John Bright, and Rudy Langlois; (second row) Tony House, Richard Pugh, Pat McClintock, unidentified, and Orris Smith. (PMC.)

Standing outside Port Orford High School are the senior-class officers for the class of 1947. From left to right are Blaine Marsh, president; Marvin Coburn, vice president (also president of the student body); Dale Howe, treasurer; and Jim Keeley, secretary. These four boys were 80 percent of the graduating class; the fifth member was Mary Hale. (PMC.)

Port Orford Grade School, now called Driftwood Elementary, opened in the late 1940s. Recent remodeling has replaced the glass bricks in the front windows with plain window glass. Interior improvements were also made as the administration prepared for fall 2009, when all Langlois students, grades K–8, were added to those in Port Orford. (PMC.)

In September 1956, Pacific High School opened just east of U.S. Highway 101 on land bought from Everett Quigley between Port Orford and Langlois. The new student body, comprising students from both communities, became acquainted and chose a name, colors, and mascot for the school, besides attending classes and studying. The consolidated school offered more courses, including physics, trigonometry, and foreign languages. The school still operates. (PMC.)

Christ Church, Episcopal, probably had the first church building in Curry County, constructed by P. J. Lindberg in 1892. Louis Knapp donated the land. The original tall steeple blew off in a storm years later and was not replaced. Another storm, on Columbus Day 1962, made the structure unsafe. The present building replaces this one. Retired bishop Thomas Jenkins, who served here in the early 1940s, renamed the church St. Christopher's. (PMC.)

Mary, Star of the Sea, also built by P. J. Lindberg, was finished in 1892 or early 1893 on Patrick Hughes's land on Cape Blanco. A Roman Catholic Church, it was used by traveling priests who held mass for families in the area. A cemetery was established beside the church. Used at least as late as 1945, the church later was abandoned and deteriorated. (Friends of Cape Blanco.)

In 1912–1913, the original Langlois Community Church (seen here) was constructed by residents who donated labor and materials. Money was borrowed from Presbyterian missions, and the church operated as a Presbyterian mission. When the mortgage was fully paid in 1946, the Langlois Community Church was incorporated. The building was used until 1957. The present church building was constructed while the Reverend Kenneth Larson was minister from 1955 to 1962. (Pastor Rick House.)

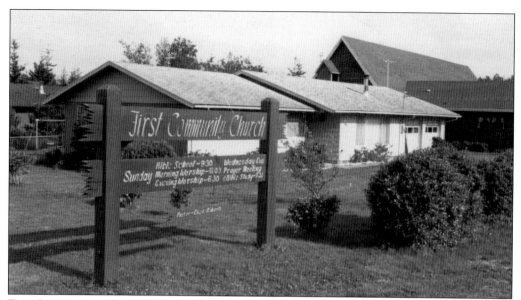

First Community Church of Port Orford was started before 1930. The people met for worship in the Episcopal church. In 1943, they bought the old Gillings Hardware Store building. Pews were boards laid across nail kegs. The church was incorporated in 1944, and in 1960–1961, they constructed their present church building at Twentieth and Jackson Streets. (PMC.)

The local Assembly of God organized in 1943. Before the church was built in 1938, on land purchased from Syneva Lindberg, the congregation met at various places, including the Langlois Community Church's first building. The present church was remodeled in the 1960s, after this photograph was taken. The Port Orford Christian Center today has programs that benefit the whole community. (PMC.)

Before 1892, a traveling priest conducted Roman Catholic mass in private homes. After Mary, Star of the Sea was built at Cape Blanco, services were sometimes held there. In 1944, this church was built beside U.S. Highway 101 and used until torn down in 1968. For some years the congregation worshiped at St. Christopher's Episcopal Church. The present building, in the original location, was erected in 1983. (PMC.)

In 1949, the Church of Jesus Christ of Latter Day Saints organized in Port Orford under the direction of Charles Saxton who served as the first branch president. The first church, purchased from Carl Leonard, had been used as a theater by Gilbert E. Gable. The new church was built in 1976 and destroyed by fire three years later. After repairs, the church was rededicated January 27, 1980. (PMC.)

The Jehovah's Witnesses established a congregation in Port Orford in the early 1950s. Meetings were held in private homes, and later they rented the old post office building. In the late 1950s, another building was rented, and in 1960, the Kingdom Hall on Myrtle Lane was constructed by the congregation. It is now a private home and Witnesses go to Bandon to worship. (PMC.)

Zion Lutheran Church began in 1952 and officially organized in 1955. They built a concrete block residence at Nineteenth and Washington Streets, used as a church school and worship setting until the first full-time pastor arrived in 1957. Then it became a parsonage as well. Volunteers built the present church, dedicated October 19, 1958, of local materials, including plywood from Western States Cooperative plywood mill. (PMC.)

Ames Johnston was first Master of Masonic Lodge No. 170, Ancient Free and Accepted Masons (AF&AM), begun in 1918. Meetings were held in different buildings; one location was above Leneve's Drug Store and another was on Jackson Street between Seventh and Eighth Streets. This building at Fourteenth and Tichenor Streets was completed by 1952. One of the lodge's prized possessions is a framed letter from Pres. Abraham Lincoln to William Tichenor in 1861. (PMC.)

American Legion Post No. 76 began in the early 1930s and received its charter about 1946. A temporary charter had been granted in 1937, when they opened their present building. Some names of charter members include Marsh, Forty, Zumwalt, Masterson, and Sauers. Area men have served in the armed forces since early days of settlement. In recent years, the Port Orford Rotary Club has refurbished the Legion building for community use. (PMC.)

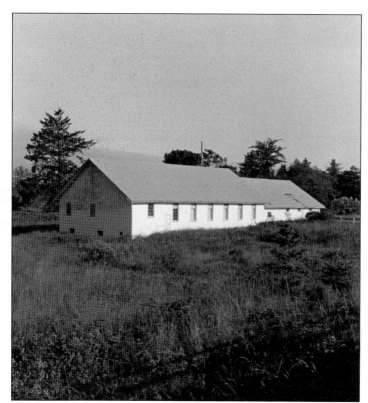

Sixes Grange No. 856 was organized in 1936. Raymond Capps was the first grange master. The group started a home economics club for women, among other activities. The grange bought land beside the Sixes River from C. C. Woodworth, who returned the money for the building fund. In 1939, the main part of the building was completed; the lower section was added in 1950. In 1979, Sixes Grange had 175 members. (POHS.)

Several couples started Beachcombers Square Dance Club in 1953. After holding dances at schools, Sixes Grange Hall, and the American Legion Hall, the club erected their own building on donated land north of Port Orford. It was completed in 1958, and the first dance was held in January 1959. The Beachcombers still dance there and elsewhere, such as in other towns and on Battle Rock Beach on the Fourth of July. (PMC.)

Eight

ARE WE THERE YET?

AFTER 1945

World War II ended, soldiers returned home, and people went on with their lives. Much like after the First World War, there was a mood of optimism and some growth in the community.

In June 1951, Port Orford celebrated the centennial of its beginning with a parade, concessions, free boat rides, historical costumes, Native American dances, and reenactments of the battle of Battle Rock. The event made a profit, which was spent the following year, 100 years after the battle. Unfortunately that celebration lost money.

Later in the decade, the town turned out again to celebrate the state centennial. Oregon became a state on February 14, 1859, but the local celebration was held on the Fourth of July, because people thought the weather would probably be better. Old-fashioned dresses were again seen on women and beards on the men. That rousing party, complete with parade and fireworks, was the first of 51 continuous years of July Fourth Jubilee celebrations.

Western States Plywood Cooperative opened on Elk River north of Port Orford in 1952. In 1955, Port Orford hosted the traveling Plywood Jubilee, celebrating 50 years of the plywood industry in Oregon.

Some disasters befell the area. The wooden city hall burned, and a new concrete one was built. The Sixes River flooded in 1961, and the Columbus Day Storm caused widespread damage in 1962.

Some successful projects were completed, too. In 1968, the U.S. Army Corps of Engineers built a jetty to protect the dock. People hailed the installation, but it had mixed results. A city park opened in the late 1970s.

In 1975, Robert E. Gable, son of Port Orford's first mayor, came to town with his family to help dedicate the new city council chambers. A little later, a new community building opened, financed by local donations. The new large space was ample for dances, concerts, plays, meetings, dinners, and other community events. A chorus, comprising members of church choirs in town, sang for a combined service held there for a standing-room-only crowd. The building still gets frequent use.

From left to right, Pearl White, Noma Thomas, and Syneva Lindberg lead a group of costumed women in the June 9, 1951, parade through Port Orford. The occasion was the celebration of the town's centennial. Other events included exhibits, a style show, a musical program, free boat rides on the bay, a dance, and Native American dances at Battle Rock with a reenactment of the original fighting. (Lucile Lindberg Douglas, daughter of Syneva.)

Adolph "Windy" Windmaiser is seen with his pipe, shovel, and gold pan following the centennial parade. He might have ridden the saddled horse behind him. Windmaiser and his wife, Lola, moved to Port Orford in retirement. He bought property for a drugstore for pharmacist Leo Phillips, worked for development of the fire department, and served as the town mayor from 1968 to 1971. (PMC.)

One of the best things to happen in Port Orford was the 1952 opening of Western States Plywood Cooperative mill on the Elk River. The cooperative employed more than 100 people, most of whom were shareholders who had paid at least $3,500 per share. The families not only increased the population of the town, but also contributed greatly to community activities. Members of the wives' auxiliary helped start an ambulance service. Due to market conditions, the mill closed in 1974. Many of the original shareholders stayed in the Port Orford area. (Alan Mitchell.)

Beginning in 1959, after the post office had moved to a new location, the building temporarily housed city offices and the library when wooden city buildings burned. The Masterson House is visible above the post office. The tall roof at left behind the White Hotel is on the old Woodmen of the World building (Camp No. 609), which Agnes Leutwyler owned for several years as a skating rink/dance hall. (PMC.)

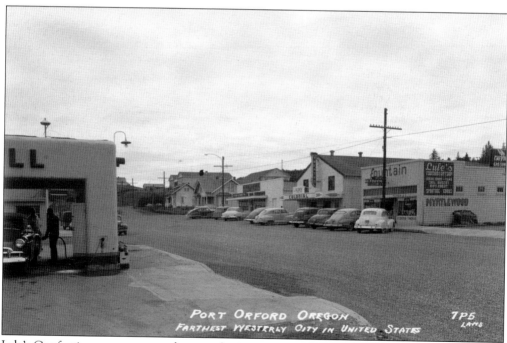

Lyle's Confectionery was a popular spot for ice cream and other treats in the 1950s. Looking south are the Colonial (now Savoy) Theater, Norm's Food Store (once Quick's Market and now entirely gone), and the 1921 Forty house. Another house built for Forty family members is beyond with the school on top of the hill. Lyle's building for several years housed Bartlett's Café, which burned in 1999. (Alan Mitchell.)

This aerial view of Cape Blanco Light Station in 1954, looking east, shows the lighthouse, two keepers' residences (which were razed in the late 1960s), communication tower and buildings, water tower, and barracks for coast guard personnel. It also shows clearly the outline of the cape—the reason why it gets some of the highest winds on the Oregon coast. The tower at the far left supports a radio beacon. Today all structures are gone from the station except the lighthouse and two garage buildings. The smaller garage houses a gift shop and small interpretive area for tourists. The lighthouse is open April 1 through October 31, six days a week. (U.S. Coast Guard Museum Northwest.)

WELCOME to . . .

Castaway BY THE SEA Lodge

Listed in A. A. A. and Gourmet's.
Guide to Better Eating.

Enjoy the Unique Stowaway Cocktail Lounge
Truly a place to remember. It's different.

HEAR THE SONG OF THE SEA!

- ◆ *MILLION DOLLAR OCEAN VIEW!*
- ◆ *Comfortable Rooms — facing the ocean or mountains. The sea will lull you to sleep.*
 Simmons Beds $3:50 to $8.00
- ◆ *Large Lobby—three fireplaces, music, home-like atmosphere.*
- ◆ *TWO DINING ROOMS—Food quality is recognized in the taste.*
- ◆ *PRIVATE PARTIES—Catering for Banquets.*

REMARKS *Noted in Our Guest Log*

"The Spirit of 'Aloha' has touched this charming place."
—Mr. and Mrs. E. J., Honolulu, Hawaii

"Came for one night; so delighted we stayed four."
—Mr. and Mrs. E. H., Columbus, Ohio.

"Heaven to a traveler; superb food"
—Mr. and Mrs. A. B., Glendale, California

"The best rest in 3,000 miles and a grand dinner."
—Mr. and Mrs. P. E., Detroit, Michigan

"Just from Arabia—none to compare with Castaway. Chicken and Crab best we ever had. Wonderful beds."
—Dr. and Mrs. G. S. D., Saudi, Arabia.

"Never had a better time in my life. Three nights here."
—E. K., Basel, Switzerland

"Most relaxing place in the Northwest."
—Mr. and Mrs. T. H., Eugene, Oregon

"A scenic bright-light on a 6,000-mile trip."
—Mr. and Mrs. H. C. T., Metarrie, Louisiana

Featuring

Week-days f

STI

Ch
crab cocktail, s
or Clam
or soup
Chef's gree
Hot Ga
Potatoes
Top Sirloin
New York (
Dessert T

$:

STI

Cut to your

$4.00

ROAST

crab cocktail, sp

Clam Chowder c
Chef's gree
Hot Gar
Roast Turkey
Potatoes
Dessert Te

$2

Clam Chowd

Crab Cocktai

Crab Cocktai

MENU

oo p. m. until Closing—

ındays and Holidays from 1:00 p. m.

BARBECUE CRAB

Choice of

ato juice crab cocktail, spiced tomato juice
er *or*
ay Clam Chowder or soup of the day
bowl Chef's green salad bowl
d Hot Garlic Bread
Vegetable Barbecue Crab and Sauce
derloin Dessert Tea, Coffee, Milk
*-Bone
e, Milk*

$2.25

PAN FRIED CHICKEN

crab cocktail, spiced tomato juice
or
ations Clam Chowder or soup of the day
 Chef's green salad bowl
) Hot Garlic Bread
 Pan Fried Chicken
 Potatoes Vegetable
 Dessert Tea, Coffee, Milk

$2.85

EY

ato juice

f the day Castaway Galley Dinner
bowl (complete dinner) .. $2.00
d
ressing Crab Louie .. _ .. $1.50
Vegetable The Fish that is Biting
e, Milk Today .. _ .. _ .. $2.00
 Complete Dinner
 Child's Plate .. _ .. $1.00
 Ham or Turkey

-

.. 50c Langlois Blue Cheese .. 20c
ll) 35c Garlic Bread .. _ .. 25c
ze) 60c Ice Cream .. _ .. _ .. 20c

Gilbert Gable's former administration building had been vacant, then owned by different people, when it was bought in 1948 by Col. Preston Rohner, U.S. Army, retired. He and his family lived in it, did some remodeling, and operated it as the Castaway Lodge and Restaurant, which was known far and wide. In 1952, they sold it and left the area. Later owners apparently let the business decline. A fire occurred when they were out of town in 1958. After two years of investigation, the couple who owned it and one other man, who was supposedly offered $1,000 to start the fire, were apprehended, tried, and sent to prison. (PMC.)

This former Woodmen of the World hall was moved about 10 blocks south on U.S. Highway 101 in about 1955. It had also served as a dance hall/skating rink; its future tenants would include a grocery store, used-car agency and shop, and art gallery. It currently contains several offices and shops and the town's little theater, Theatre 101. (Lucile Lindberg Douglas.)

Originally housing Paul Leutwyler's first Battle Rock Garage in the 1920s, this building became a restaurant after Leutwyler moved out in 1940. Orford's served customers for many years and was a town landmark. In later years, the building housed a gift shop specializing in candles and clothing items. It was recently renovated to be a fine art gallery. The building at right housed the Community Apartments. (POHS.)

Charlie Jensen grew up in Denmark, Oregon. He studied and taught music (including to his own seven children), played in dance orchestras, and sold instruments. Beginning in 1949, he taught in Port Orford-Langlois schools for 11 years. Jensen (left) presents the 1958 John Philip Sousa Award for outstanding musicianship to Judy Jensen and Judy Marsh. Wilbur Jensen, the 1956 recipient, is at right. (Wilma and Charlie Jensen family.)

Charlie Jensen's music store was in Port Orford from 1960 to 1963. This building was, at one time, the Sears store and is today an antique store. The Jensen store moved to North Bend, Oregon, to Pony Village Mall from 1963 to 1967. Jensen organized a community band of "Jensen Family and Friends," which has played in Port Orford's Fourth of July parade since 1952. (Wilma and Charlie Jensen family.)

One of the Fourth of July parade entries in the 1950s was the town's old fire truck from 1938, when the volunteer fire department was organized with six members. Dr. Richard Pugh and Frank Tichenor had bought the body of the truck and, a year later, bought a Ford chassis for it. (PMC.)

The city passed a bond issue to purchase a newer truck. With donated time and labor, this three-stall garage was built at Ninth and Idaho Streets. The Diamond T fire truck is at the left, with a 1948 Chevrolet pickup next. The last stall on the right houses the community Cadillac ambulance, pictured at right. The siren was used on a later (current) fire hall. (George Gehrke.)

After a 1958 fire destroyed wooden city hall buildings, less than 40 percent of Port Orford voters turned out to defeat a bond measure for a new city hall, jail, and library. In 1961, a committee made new plans, and with donated land and money, a building was constructed and opened in April 1962 (the near portion shown in this photograph). It has housed city offices, a library, and the judge's chambers. (PMC.)

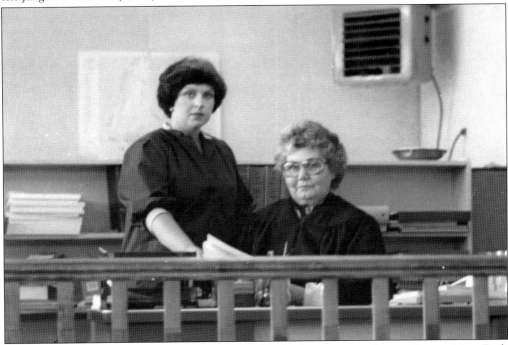

Georgia Dougherty was city judge around 1962. She had a reputation for toughness. Mary Beth Goergen is standing beside her in the city hall. Some local people remember appearing before Judge Dougherty. (PMC.)

An unusually severe windstorm blew through most of western Oregon on October 12, 1962. The "Columbus Day Storm" caused widespread damage. The White Hotel at the corner of U.S. Highway 101 and Jackson Street was missing windows. The upper part of the old Leneve Building was damaged behind the false front and twisted sign. Lena Herzig, inside the collapsed clothing store, was rescued, unhurt. (Lucile Lindberg Douglas.)

Lucile Lindberg Douglas was inside this building at U.S. Highway 101 and Tenth Street during the height of the storm, staying as far from windows as possible. The building, now a hardware store, was the office for the Coos-Curry Electric Cooperative in 1962; Lucile was an employee. Pacific High School, north of town, sustained significant damage; several homes were destroyed, as well as fishing boats, trailers, and other structures. (Lucile Lindberg Douglas.)

The fire station was built just south of the city hall after 1962. An empty space remained between the fire hall and city offices. The siren on the roof came from the old fire station. Today the Port Orford Volunteer Fire Department still occupies the space, along with an ambulance service, also operated by volunteers. All firefighters and emergency medical technicians receive regular high-quality training. (PMC.)

This 1,000-gallon pumper was purchased for the city around 1970. Standing beside it are, from left to right, Randy Foster, Dennis Gehrke, and Jim Owen of the Port Orford Rural Volunteer Fire Department. Behind the pumper is a truck purchased in about 1980. (PMC.)

In the early 1970s, community effort and library board determination led to filling the space between the city hall and fire hall. In 1973, the public library moved into quarters on the east side of the new addition. The west side (shown here) was occupied by city council chambers, named for Gilbert E. Gable and dedicated in November 1975. Gable's son Robert and his family visited and participated in the dedication and related events. Visible behind the desks are the myrtlewood chairs for mayor and councilors, built for the first city hall in 1935. The council chambers are still in use today. (Both, PMC.)

Chetco Federal Credit Union, started in Brookings at the south end of the county in 1959, opened a branch office in Port Orford in February 1985. Inside the new office are, from left to right, Pam Evans, Port Orford loan officer and later branch manager; Pat Widmer, CEO of Chetco; Kurt Lunsford, vice president of Chetco; Frances Smith, branch manager; Sam Cuatt; Lester Lefter; and Lyle Knutson. (PMC.)

Coos-Curry Electric Cooperative started in Coos County in 1939, after years of grassroots efforts, and Curry County became part of it in 1947. In 1983, a new headquarters building for the cooperative was constructed north of Port Orford and is in use today. The cooperative serves more than 14,000 people in the two counties. (PMC.)

www.arcadiapublishing.com

Discover books about the town where you grew up, the cities where your friends and families live, the town where your parents met, or even that retirement spot you've been dreaming about. Our Web site provides history lovers with exclusive deals, advanced notification about new titles, e-mail alerts of author events, and much more.

Find Your Place in History.